D1014025

Cascade County and Great Falls

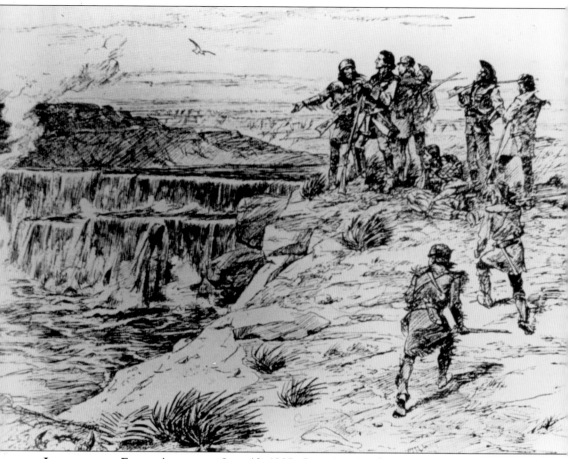

LEWIS AT THE FALLS. At noon on June 13, 1805, Capt. Meriwether Lewis with four men from the Corps of Discovery stared in awe, as Lewis wrote, "a sublimely grand specticle [*sic*] . . . the grandest sight I have ever held." These trailblazing explorers became the first white men to view the Great Falls of the Missouri River, drawn in this image by cowboy artist Charles M. Russell in 1899.

ON THE FRONT COVER: Lapeyre Brothers Druggists opened in 1886 at the 400 Block of Central Avenue, the first pharmacy in town. Alexander and Benjamin Lapeyre saw their business expand quickly and moved to this larger brick building in 1890 at the corner of Central Avenue and Third Street. This August 13, 1914, scene, entitled "The Greatest Pageant in Montana History," is of a golden jubilee celebration marking Montana Territory's 50-year anniversary and Montana statehood's 25th anniversary. (The History Museum.)

ON THE BACK COVER: Wandering, landless Indians are camped east of Great Falls. From its beginning, Great Falls was "home" for many Native Americans without reservations, primarily from the Cree and Chippewa tribes and Metis. In recent decades, Blackfeet (Siksika), Gros Ventres (A'aninin), and other Native Americans also have a substantial presence in Great Falls. The 2000 census recorded a Native American population of five percent in Great Falls. (THM.)

POSTCARD HISTORY SERIES

Cascade County and Great Falls

To Preserve & Protect!

Ken Robison

Ken Robison

ARCADIA
PUBLISHING

Copyright © 2011 by Ken Robison
ISBN 978-0-7385-8192-7

Published by Arcadia Publishing
Charleston, South Carolina

Printed in the United States of America

Library of Congress Control Number: 2010934145

For all general information, please contact Arcadia Publishing:
Telephone 843-853-2070
Fax 843-853-0044
E-mail sales@arcadiapublishing.com
For customer service and orders:
Toll-Free 1-888-313-2665

Visit us on the Internet at www.arcadiapublishing.com

*To Karin and her new adventure, Mark and his delightful
boys Perry and Turner, and to Ken and Ellen Sievert,
Montana's premier historic preservationists*

CONTENTS

ACKNOWLEDGMENTS

My appreciation to the following:

Our dedicated members of the Great Falls/Cascade County Historic Preservation Advisory Commission (HPAC) who work with me to preserve historically important buildings, sites, and landmarks in the city and county; our Historic Preservation Players, Bruce Cusker, Bob Milford, and Carol and Bill Bronson, for joining in the fun as we educate, "How Great Falls REALLY Began!"; our broad coalition for tirelessly working to protect the Great Falls Portage National Historic Landmark; Rev. Bob Payne, Rev. Mercedes Tudy-Hamilton, and Frank and Mary Ghee for building on the historic treasure Union Bethel African Methodist Episcopal Church; Philip Aaberg, Jack Mahood, and Chris Morris for joining me in bringing the amazing Ozark Club and its story back to life; Sugar, Mollie, and Bunny LaMar for sharing their knowledge of the remarkable Leo LaMar and his Ozark Club; Judy Ellinghausen for her talent and enthusiasm in making the resources of The History Museum (THM) available to all; Great Falls Public Library for maintaining The Montana Room, my home away from home; Reporters, past and present, including Paula Wilmot, Karen Ogden, Richard Ecke, and Kim Skornogoski for bringing history to life in the *Great Falls Tribune;* photographers, past and present, Ray Ozmon, Stuart White, Wayne Arnst, Larry Beckner, and others, for capturing history through their imagery; William J. Furdell for raising the bar for early pictorial histories through his book, *Great Falls: A Pictorial History;* Niel Hebertson for a decade making Fireside Books a Mecca for book enthusiasts of all interests and ages; Andrew Finch for his knowledge of and enthusiasm for Great Falls history and the use of his postcards; Ike Kaufman for anchoring downtown Great Falls and sharing his love of history; Bill Ukrainetz, Jim Eakland, Margaret Ganger, and Ursuline Sisters, for use of their treasured images; Tom Mulvaney, Montana's premier postcard collector, for kindly permitting use of his personal collection of postcards; John Poultney and the staff at Arcadia Publishing for their technical assistance; And the best for last, my wife and world-travelling companion, Michele, for our life of love and shared adventures.

Unless otherwise noted, all images are from the author's collection.

Although many have helped, this author bears all responsibility for the many facts and opinions stated within.

INTRODUCTION

One cold winter day in 1870, pioneer Robert Vaughn mounted his gray mustang and rode to the summit of a hill to gaze down on the confluence of the Missouri and Sun Rivers for the first time. What a sight he saw. On the south side of Sun River (called Medicine River by Native Americans) Vaughn observed an Indian village, two tepees on the north side of the Missouri River and one just east on Indian Point. The latter sheltered a lookout to watch for the approach of enemies and track the direction of buffalo herds.

On Prospect Hill to the south was a herd of antelope, and down near the river a herd of buffalo moved in single file toward the water and the ford in the Missouri River. In a grove nearby, bison rubbed against cottonwood trees. Farther east in the vicinity of what became Boston Heights, several hundred more fed on the grasses of the bench lands. Vaughn was looking at the site of the future city of Great Falls.

Great Falls, at the head of five falls of the Missouri River and the confluence with the Sun River, became the city of wind, water, and future. With the development of Great Falls, the county of Cascade was formed, and the economy of both city and county became intertwined.

As a friend of Great Falls and great historian Stephen Ambrose once said, "History is everything that ever happened." It is up to the historian to seek the truth from "everything" and present digestible portions for the reader to enjoy and learn. This book samples the past of Cascade County and Great Falls—the good and the bad. We should celebrate the good, learn from the bad, and move forward together.

For centuries the Blackfoot, Crow, Gros Ventres, and other tribes moved across the ford above the great falls of the Missouri River. At times, battles between Blackfoot and Crow raged at the site of the future city and up the Sun River Valley. The Vivendi Archeological Site on the northwest bank of the Missouri River yielded proof that Native American hunters camped here some 2,500 years ago.

The Lewis and Clark Corps of Discovery spent 31 days portaging around the great falls in June and July 1805. Gov. Isaac I. Stevens, with artist Gustavus Sohon, who saw and painted the first known image of the great falls, and Lt. John Mullan, who surveyed the general area, passed through in 1853–1854. Mullan returned in 1860 with his expedition to build a military wagon road from Fort Walla Walla in the Washington Territory near the Columbia River, to Fort Benton, head of navigation on the Missouri River. Fur traders and Jesuit priests came and went with wary eyes toward warriors of the Blackfoot Nation. The gold strikes at Gold Creek and Grasshopper Creek in the summer of 1862 opened a flood of miners, merchants, and adventurers that would follow. That same summer, a party of 11 from Fort Benton visited the great falls, including young Margaret Harkness, the first white woman to view the falls.

White settlement in the Sun River Valley and along Mullan Road was underway in the 1860s. St. Peter's Jesuit Mission moved three times until finally locating west of today's town of Cascade. Troubles between white settlers and the Blackfoot during the middle to late 1860s

led to construction of Fort Shaw in 1867 above Sun River Crossing. These troubles subsided as a result of the tragic Baker Massacre in 1870. With reduction of warfare and of the buffalo herds, ranching opened up in Sun River, the Missouri River Valley, the Chestnut Valley, the Shonkin, and Highwood areas. Towns at Sun River and Fort Shaw developed. By 1880, miners stampeded to remote outposts like Yogo and Clendenin in the Little Belt Mountains, chasing precious minerals.

As Robert Vaughn observed, the spot on which the city of Great Falls was to be located is a picturesque place on the bend of the Missouri River just below its confluence with Sun River where the foot of Long Pool widens to form lake-like Broadwater Bay. It is just above Black Eagle Falls, the first of the series of magnificent falls that give the town its chief reason for being. The site lies on a gentle slope rising from the riverbank to the plains east and south with a stunning view of the valley of Sun River, the Rockies to the distant west, and the Belt and Little Belt Mountains to the south. Bluffs on the north and west follow the course of the river except for the break formed by Sun River Valley.

The banks of the Missouri River were lined with cottonwood trees, willows, and small brush, and the land north of lower Central Avenue was a grassy marsh. There were innumerable springs bursting forth from the east and south slopes and on the bottomlands. White Bear Island lay in Long Pool above the mouth of Sun River. Gravelly Prospect Hill, called Lookout Butte by the Blackfoot, was south, while north across the river was Indian Point, later called Smelter or Anaconda Hill.

Where the Missouri River narrowed below Broadwater Bay to form rapids in its rocky ledges, its course became shallow and was used by countless herds of buffalo as a ford. Down the river on its south bank was the Giant Springs remarkable for its beauty and volume of its flow, the largest freshwater spring in the United States.

The most remarkable features were the five falls of the Missouri River: Black Eagle, Colter's, Rainbow, Crooked, and Great Falls. From time immemorial the river dashed over the precipices in clouds of foam and spray presenting a spectacle of beauty and grandeur unrivaled in nature.

Where Great Falls is now, immense herds of buffalo once crossed the Missouri River on their way from the high plains along the eastern front of the Rockies to their summer grazing grounds in the Judith Basin and the Musselshell Valley and were in turn followed by the Blackfoot that lived on the plains east of the Rockies, and the Salish, Kutenai, Nez Perce, and Pend d'Oreille tribes from the valleys west of the Rockies on their hunting expeditions. The fording place, where today's Burlington Northern railway bridge crosses the river directly above the first rapids, was the only shallow crossing for nearly 40 miles in either direction and was marked by deep-worn trails. The Gros Ventres and the Crow frequently came northwest to hunt the buffalo when they returned to the northern plains. It was inevitable that the region near the ford should be the scene of many bloody encounters between the hostile tribes that met here.

The Mandan Indians told Lewis and Clark about the falls, describing the cottonwood tree with the black eagle's nest in it on the island below the uppermost falls. When their expedition reached the vicinity of the falls, they portaged from the mouth of Belt Creek to a point opposite White Bear Island above the present city where they made camp and celebrated the Fourth of July in 1805—the first ever observed in Montana. Lewis and Clark's portage route now is commemorated by its designation as the Great Falls Portage National Historic Landmark.

From the arrival of Paris Gibson at Fort Benton in Montana Territory in 1879, the birth of a city at the falls of the Missouri River became inevitable. Gibson had watched the growth of Minneapolis from village to city in just two decades. After viewing the falls of the Missouri River and discussing the potential with old timers like John Castner of Belt and Robert Vaughn of Sun River, Paris Gibson determined to found a "Minneapolis of the West."

After forming a partnership with railway magnate James J. Hill, in the summer of 1883 Paris Gibson sent surveyor and lawyer Herbert P. Rolfe to survey the site for a city. On August 4, 1883, Rolfe wrote a letter to his wife, Martha, from the site of present-day Great Falls in which he crossed out "Fort Benton" from his printed letterhead and wrote in "Great Falls."

During the spring of 1884, a handful of tents and claim shacks appeared at the site of the new "city." Fort Benton carpenter Josiah Peeper built a small log cabin on the south side of the Great Falls townsite. This first known permanent structure, now named the Vinegar Jones Cabin for its longtime owner, Whitman Gibson "Vinegar" Jones, has survived the years, elements, fires, and demolition permits, and is now located in a place of honor in Great Falls' premier Gibson Park.

The year 1884 saw other limited building when William Wamer erected a small board and canvas shack on what became Second Avenue South, for use as a restaurant and hotel. This first "hotel" allowed residents to sleep in the loft or on the floor. The Wamer shack stood only a year before it burned to the ground. Herbert P. Rolfe built a claim shack on his homestead east of the townsite, now 2604 Third Avenue South, and brought his family from Fort Benton. George E. Huy's shack followed Rolfe's, and then the Great Falls Townsite Company moved from their tents on Broadwater Bay into a small office opposite the future site of the Park Hotel. James Walker and Thomas C. Carter opened a restaurant built of boards and canvas at the corner of Third Avenue and Third Street South. Ira Myers brought a portable sawmill and commenced operations near today's city water works. On October 22, Murphy and Maclay opened a store, built by Vinegar Jones, with Worden P. Wren in charge. Howard Criss floated lumber down the river and built a blacksmith shop on the corner of Third Avenue South and Third Street.

Across the river, a rival town of Johnstown, named for John Largent of Sun River, had begun a year earlier. A store and restaurant were added to its facilities, and a regular stage service began with Sun River. Soon Johnstown acquired the first post office, and a ferry started operating between Johnstown and Great Falls.

A school district was formed in 1885, and a log schoolhouse opened in the fall. Vinegar Jones had begun construction of a flourmill in the fall of 1884 for Herbert O. Chowen and a Mr. Jamison. To celebrate, a grand ball was held March 17, 1885, to dedicate the mill. A large crowd braved cold weather. Will Hanks moved his weekly newspaper from Sun River, and the *Weekly Tribune* began publication on May 14.

The first Fourth of July celebration in Great Falls was held in 1885. The 150 residents held an impromptu celebration with speeches all day long, given in the town's three saloons. For fireworks, Fort Shaw soldiers stole into town in the dead of night, blasting cannonballs right down Central Avenue.

From its founding in the spring of 1884, the town of Great Falls grew very slowly, drawing the derogatory nickname "the future great" from older towns Fort Benton and Sun River. The arrival of Jim Hill's St. Paul, Minneapolis & Manitoba Railway in October 1887 changed all that and the dream of growth became reality. Cascade County broke away from four counties, primarily Choteau County, on December 3, 1887.

By the early 1890s, waterpower was being harnessed and mineral smelting operations were underway. The founding settlers of Great Falls came from every direction, with some from Fort Benton, Helena, and the Sun River Valley, others from Minneapolis and elsewhere in the Midwest, Canada, and the East. When industrial refineries and smelters began operations in the 1890s, many immigrants came across the Atlantic Ocean to seek opportunity in this new land.

And so the story of the city of Great Falls and the county of Cascade begins. It is the story of opportunity and growth and many great accomplishments. It is also the story of economic "busts," hard times, wars, and occasions of man's inhumanity to man. Many of the scenes that follow are from the early years and the early 1900s, periods of growth and prosperity. Some are views of grand buildings with Victorian, Romanesque, and Classical Revival styles that led Mark Twain on his visit to the new town in 1895 to remark, "Great Falls is one of the prettiest towns in the West, resembling Denver of a few years ago, except that the buildings are finer than those in Denver."

Many of the images you will see are from postcards that were coming into widespread use 100 years ago. Today it is difficult to appreciate postcards when they were first in use so long ago. The *Daily Missoulian* in 1911 wrote, "Picture postcards have been like a delightful vice that

we first endured, pitied, then embraced. We were inclined to regard the first crude output of them as makeshifts for the lazy and picture cards for the children. Little by little they got in their insidious work—they were such blessed time-savers, they were such inexpensive souvenirs for the folks at home, they were such suggestive mementos of travel! And now we have found that there is no end to their uses, and we buy them by the cartload."

The images and stories in this book were selected to spotlight not only Paris Gibson, the visionary, and other founders, but also to spotlight workers of all walks of life: the iron worker, the smelter worker, the miner in the mountains, the cowboy on the range, the farmer in the fields, the women blazing new paths, the troops marching off to war. These images tell the stories of the booming homestead years of the 1910s and the homestead "bust" in the early 1920s, stories of the teachers, nurses, nuns and priests, the jazz players, the gamblers, the prostitutes, the baseball players, and ice skaters. So many stories—so little space.

Great Falls has been known as the City of the Falls, the Cataract City, and the Electric City, but today it is more. Great Falls has had an industrial and railroading past, but these have faded. Cascade County has broad regional agricultural farming and ranching that through good years and bad years provide a solid economic base. Great Falls has Montana's largest military presence with the 120th Fighter Wing Montana Air National Guard at Gore Hill and the 341st (Minuteman) Missile Wing and RED HORSE Squadron at Malmstrom Air Force Base bringing a wealth of national and ethnic diversity to the community. Great Falls has Montana's greatest ethnic diversity with the largest Native American and African American populations in the state. The sports scene features national champion figure skaters and a baseball team of future major leaguers. A strong cultural environment is highlighted by the renowned Charles M. Russell Museum and a Symphony that attracts the quality of Yo-Yo Ma. Today Great Falls has the river, the falls, the springs, the magnificent River's Edge Trail, and an enormous economic potential focused on recreational and cultural tourism. Great Falls is Montana's "All-American City."

One

"WHEN THE LAND BELONGED TO GOD"
NATIVE AMERICANS AND BISON

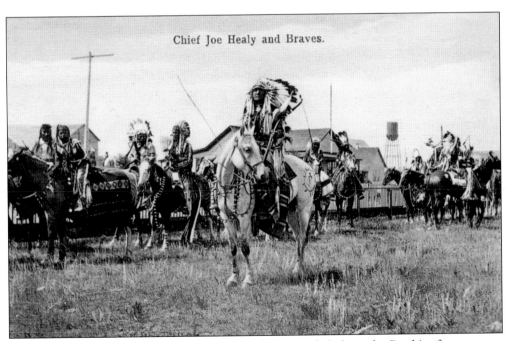

Chief Joe Healy and Braves.

BEFORE THE WHITE MAN. The Blackfoot Nation extended along the Rockies from present Alberta, Canada, southward across "the Medicine Line" into present Montana to the Musselshell River and Three Forks of the Missouri River. Allied with the Blackfoot nation were the Atsina, or Gros Ventres, and the Sarcee, or Sarsi.

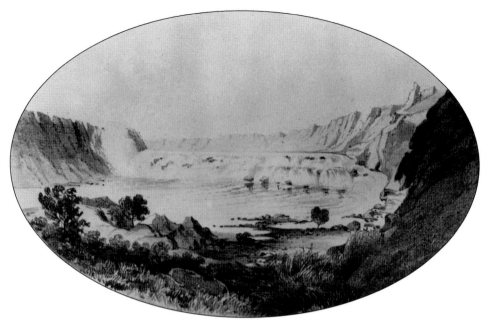

GREAT FALLS OF THE MISSOURI. In 1854, Gov. Isaac I. Stevens, while exploring this region for a northern railroad route, examined the falls of the Missouri River. Artist Gustavus Sohon accompanied Steven and painted a watercolor of the great falls of the Missouri River. His painting was made into a lithograph for use in the published Pacific Railway Survey Report and is the first known image of the great falls.

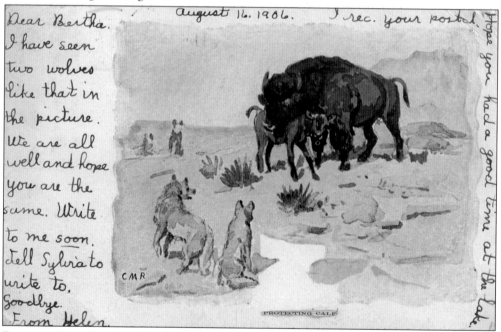

BUFFALO. Bison dominated the landscape in the early West shaping the lives of native peoples for centuries before arrival of whites. Bison symbolized the West, providing sustenance for Native American, and the passing of the bison profoundly changed the West. This 1906 undivided back postcard illustrates how the writer is able to identify with the scene on the card.

FIRST PEOPLES PISKUN. The First Peoples Buffalo Jump State Park, formerly Ulm Piskun, is an archaeological site at a mile-long sandstone cliff, possibly the largest bison jump in North America. Blackfeet and other tribes used this site for more than 2,000 years. The park has an interpretive trail and an education center highlighting Native American and buffalo cultural exhibits. (THM.)

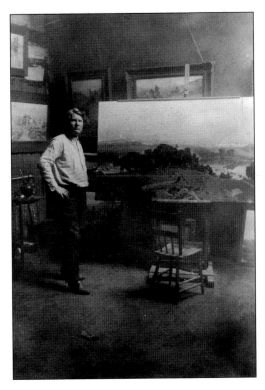

WHEN THE LAND BELONGED TO GOD. No American artist captured the early west better than Charles M. Russell. In his studio cabin in Great Falls the "cowboy artist" stands next to his 1914 masterpiece "When the Land Belonged to God," showing an endless line of bison crossing the Missouri River. Charlie Russell understood the importance of the bison to Native Americans and lamented the passing of the bison from the scene.

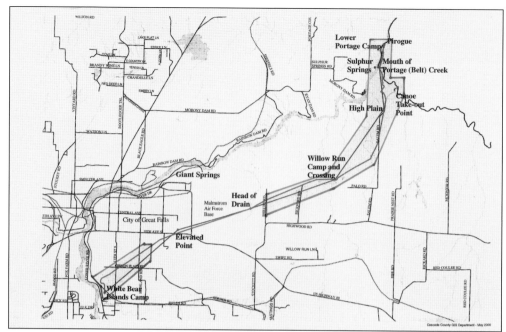

GREAT FALLS PORTAGE NATIONAL HISTORIC LANDMARK. By mid-June 1805, the Lewis and Clark Expedition reached the falls of the Missouri River, and a difficult, dangerous 18-mile portage began around the falls. For 31 days of backbreaking work, the men hauled their boats and supplies overland and back to the Missouri River at White Bear Island. On July 15, the explorers set out upstream. The Great Falls Portage National Historic Landmark was designated in 1966 to honor their undaunted courage. (Historic Preservation Advisory Commission HPAC.)

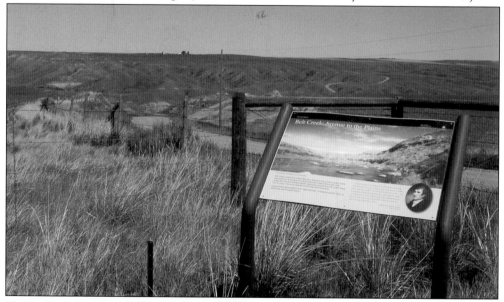

UPPER PORTAGE CAMP. The Lewis and Clark Expedition took their boats out of the Missouri River at Portage (now Belt) Creek, the lower campsite. Dragging the boats and cargo up the steep bluffs of Portage Creek, the explorers reached the Upper Portage Camp shown in this scene. (Ken Robison.)

14

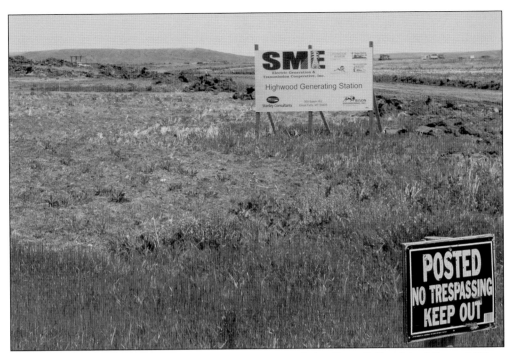

ENDANGERED LANDMARK. The arduous portage around the Great Falls of the Missouri River became Lewis and Clark's most remarkable physical triumph of the expedition. Two miles south of Upper Portage Camp, on the edge of the National Landmark, Southern Montana Electric Cooperative is building a Highwood Generating Station (HGS), which will have an adverse and significant impact on the Great Falls Portage Landmark. (Ken Robison.)

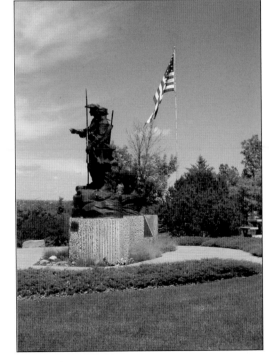

LEWIS AND CLARK MEMORIAL. A memorial to the Lewis and Clark Expedition stands prominently in Great Falls Overlook Park with a huge American flag in the background. The memorial by Montana's premier sculptor, Robert M. Scriver, is titled "Explorers at the Portage" and features Captains Meriwether Lewis and William Clark, Clark's slave York, and Seaman the dog. (Ken Robison.)

LEWIS AND CLARK INTERPRETIVE CENTER. Located, and almost hidden on a bluff overlooking the Missouri River, just above Giant Springs, the Lewis and Clark National Historic Trail Interpretive Center opened in 1998. The Center features the Expedition's portage around the Great Falls of the Missouri River, the Expedition's journey from St. Louis in 1804 to the Pacific Ocean and back to St. Louis in 1906, and celebrates the spirit of discovery through exhibits, films, and live presentations. (Ken Robison.)

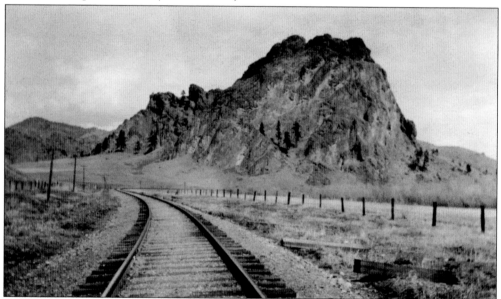

TOWER ROCK. Located on the Missouri River near Hardy Creek, this formation is designated Tower Rock State Park. On July 16, 1805, Captain Lewis wrote, "At this place there is a large rock of 400 feet high which stands immediately in the gap which the Missouri makes on its passage from the mountains . . . this rock I call the tower . . . and from there is a most pleasing view of the country." Tower Rock is where the Corps of Discovery left the plains and entered the mountains. (THM.)

150TH ANNIVERSARY
MULLAN ROAD CONFERENCE
1860 - 2010

FT. BENTON

FORT BENTON, MT
20-22 MAY
2010

FT. WALLA WALLA

JOHN MULLAN. The Mullan Military Wagon Road was the first wagon road to cross the Rocky Mountains from the head of navigation on the Missouri River to the head of navigation on the Columbia River. Leaving Fort Walla Walla in Washington Territory in June 1859, 1st Lt. John Mullan led an expedition that carved a 624-mile wagon road through the mountains of Idaho into Montana, through the Sun River Valley, arriving at Fort Benton on August 1, 1860. (David Parchen.)

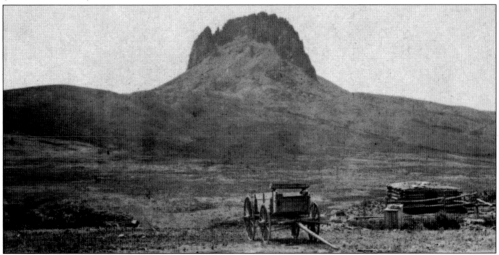

BIRDTAIL ROCK. As the Mullan Expedition moved north from the Dearborn River to Sun River, the explorers used the spring at the top of Birdtail Divide and then moved on to camp on the north side of this classic prominent geological feature, Birdtail Rock. In late July 1868, Salt Lake photographer Charles R. Savage photographed this classic scene. As Mullan Road evolved into Montana's Benton Road, many travelers stopped here along the way to admire the view. (Charles R. Savage.)

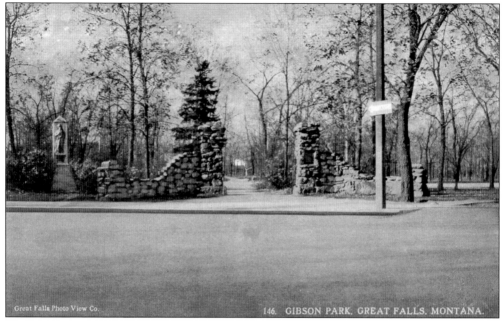

Great Falls Photo View Co.

146. GIBSON PARK, GREAT FALLS, MONTANA.

MULLAN MONUMENT. During the expedition, Mullan and his military and civilian work force hacked a 25-foot wide road through 125 miles of timber, and dug 30 miles of excavation along mountainsides. The American Society of Civil Engineers designated the Mullan Road a Historic Civil Engineering Landmark in 1977. In this postcard, on the left of the old south entrance to Gibson Park stands the marble obelisk with bas-relief figure of Capt. John Mullan dedicated on December 3, 1916. (Great Falls Photo View Company.)

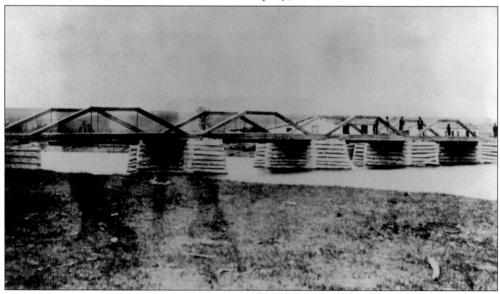

SUN RIVER CROSSING. In 1858, Blackfoot agent Col. Alfred J. Vaughn established a government farm just above the natural ford called Sun River Crossing. Colorful John Healy set up a trading post on the north bank of the ford where Gen. Thomas Francis Meagher spend his last week before his mysterious death in Fort Benton on July 1, 1867. This wooden toll bridge was built at the crossing in 1868–1869. (Overholser Historical Research Center, or OHRC.)

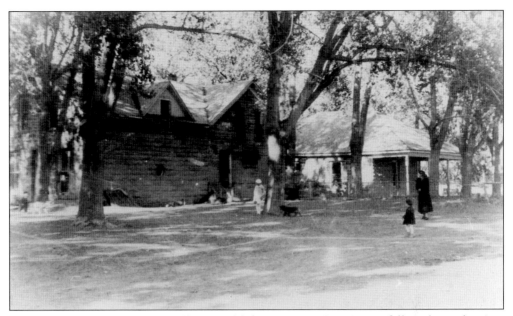

SUN RIVER LEAVINGS. The Mullan Road left Sun River Crossing to follow down the river along the north bank. At the end of Sun River Valley, known as Sun River Leavings, the road left the river to head northeast toward Benton Lake. This site became a stage stop, inn, and store owned by Thomas C. Power. Today this is near the town of Vaughn. (OHRC.)

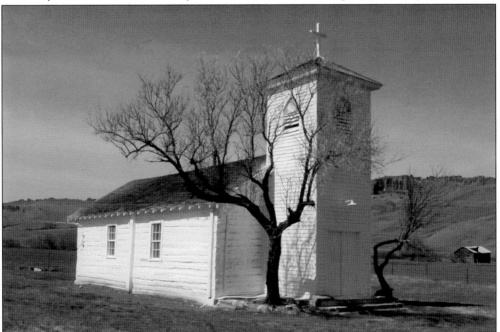

ST. PETER'S MISSION. St. Peter's Mission, a Jesuit mission among the Blackfoot, was relocated three times before settling near Birdtail Rock and the Mullan Road. The mission opened in 1866, but hostilities forced closure until 1874. After reopening, the mission expanded into a major complex with schools and a convent. This historic church was added to the National Register of Historic Places in 1984. (Ken Robison.)

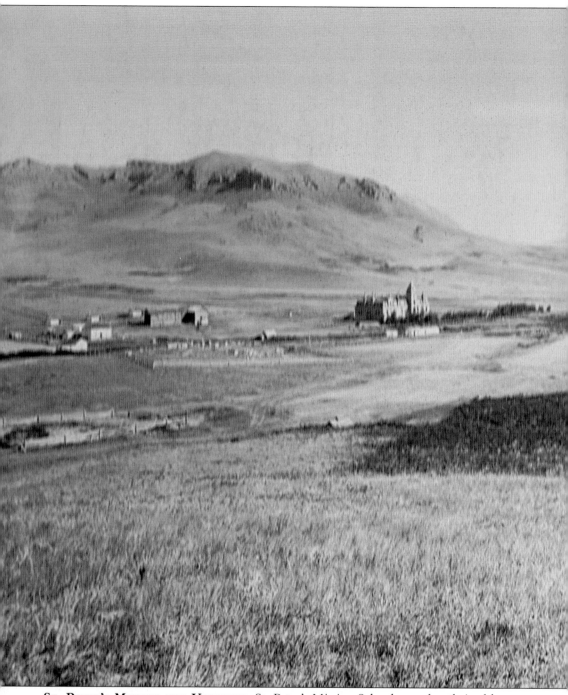

ST. PETER'S MISSION AND URSULINE. St. Peter's Mission School complex thrived between 1866 and the early 1900s. Begun by Jesuits, the mission expanded greatly in the 1880s with the arrival of Ursuline Sisters led by Mother Amadeus in October 1884. This grand scene shows St. Peter's Cemetery (far left), the Ursuline Convent and Mount Angela Academy for Girls (left center), the Mission School for Boys and Priests Residence (right center), St. Peter's Church and original Indian School (far right). During 1883–1884, famed Metis leader Louis Riel taught

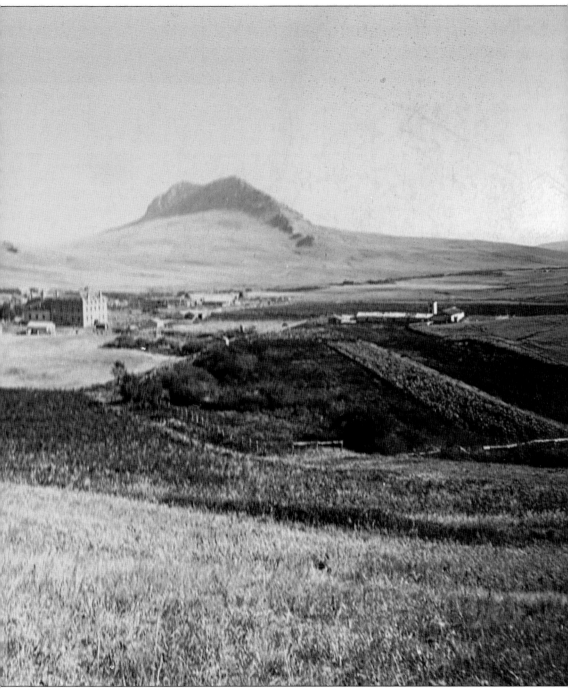

in the boys school until his departure for Canada to lead the Metis and Cree in the Red River Rebellion. The rebellion failed, and Louis Riel was hanged although many of his followers took refuge across the Medicine Line in Montana. During the 1880s and 1890s, the Ursuline Sisters established boarding schools for daughters of white settlers and native children, and the Jesuits expanded their school for boys.

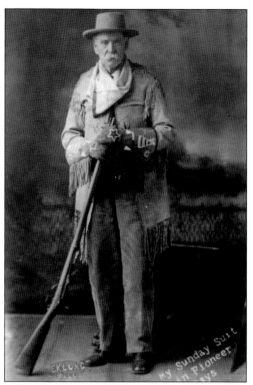

ROBERT VAUGHN. Born in Wales in 1836, Robert Vaughn came to the United States in 1858 and west to the new Montana Territory by overland wagon in 1864. One of the first homesteaders and ranchers in the Sun River Valley, in 1900 Vaughn published his reminiscences of early life in territorial Montana in the book *Then and Now.* Friend and advisor to Paris Gibson in founding Great Falls, Vaughn invested in the new city and passed on in March 1918. (Hilare C. Eklund.)

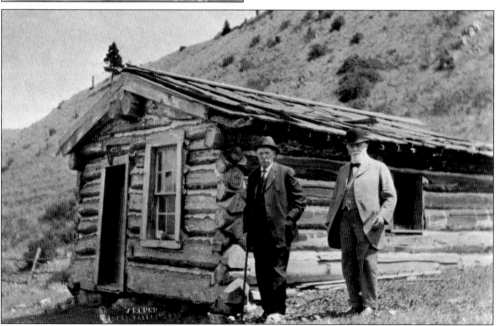

EARLY SUN RIVER VALLEY CABIN. In the fall of 1869, Robert Vaughn settled in the Sun River Valley, locating a ranch north of the river near Sun River Leavings on Montana's Benton Road. Vaughn built this log cabin on his ranch, which was the first land entry made in what was then Choteau County. Standing by the cabin are elderly pioneers Robert Vaughn, left, and lumberman Anton M. Holter. (Hilare C. Eklund; THM.)

Two

"THE FUTURE GREAT"
THE FOUNDING OF GREAT FALLS

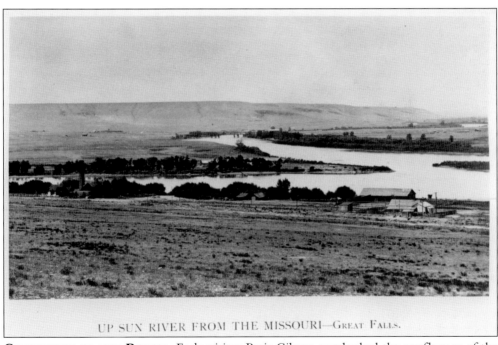

UP SUN RIVER FROM THE MISSOURI—GREAT FALLS.

CONFLUENCE OF THE RIVERS. Early visitor Paris Gibson overlooked the confluence of the Missouri and Sun Rivers and said, "Before me I saw a plain, unbroken by ravines, gently descending for a distance of two miles to the broad Missouri with its low, grassy banks, while beyond, I beheld the Sun River as it runs through the beautiful valley and unites its waters with those of the great Missouri." (THM.)

PARIS GIBSON, VISIONARY. In 1882, Paris Gibson, then living in Fort Benton, visited the great falls of the Missouri River. Standing on the heights overlooking the confluence of the Missouri and Sun Rivers said, "This scenery, composed of valleys and rivers, flanked by smoothly rounded tablelands, formed a picture never to be forgotten. As I looked upon this scene I said to myself, 'Here I will found a city.' "

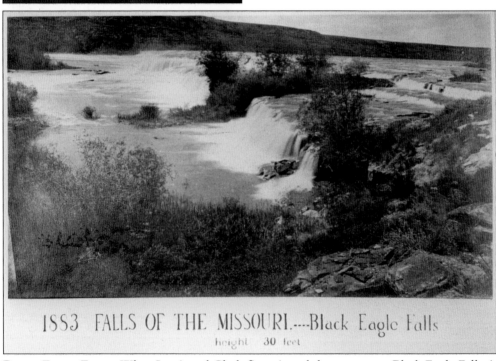

1883 FALLS OF THE MISSOURI.----Black Eagle Falls
height 30 feet

BLACK EAGLE FALLS. When Lewis and Clark first viewed the uppermost Black Eagle Falls, it must have looked much as it did in this 1883 image. Named by Lewis and Clark for the eagle they viewed nested on an island just below the falls, Black Eagle Falls proved ideal for development of the first dam in Montana to provide hydroelectric power for the early growth of industry and the new town. (THM.)

HERBERT P. ROLFE, SURVEYOR. By 1882, Paris Gibson found just what he needed as a confidant, surveyor, and lawyer to help translate his vision of a city into reality—Herbert P. Rolfe. Young Rolfe, with his wife, Martha, daughter of Montana's first territorial governor Sydney Edgerton, and their four daughters became key parts of Gibson's plans. In July 1883, Gibson sent Rolfe in secrecy with a team to survey and plat "a Minneapolis on the Missouri."

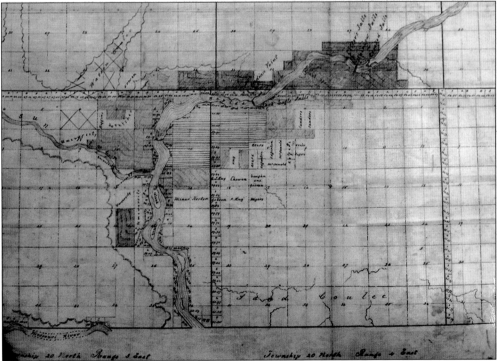

SURVEY MAP, 1883. During July and August 1883, Herbert P. Rolfe and his team surveyed the area of the prospective town. The Rolfe survey shows areas for industry north of the river, a townsite centered on Central Avenue, a major university on the southwest side, and other features. On August 4, Rolfe wrote a letter from the survey site to his wife in which he crossed out the words "Fort Benton" and wrote in "Great Falls," likely the first use of that name. (Thomas Minckler.)

First Townsite Office. The spring of 1884 saw the beginning of construction of the townsite of Great Falls. Operating from two tents on the shore of Broadwater Bay, the Great Falls townsite opened its first office. After a long, hot summer in the tent, the Townsite Company moved into its new office on Central Avenue. Paris Gibson, James J. Hill, and Conrad Gotzian, a wealthy man from St. Paul, financed early Townsite Company operations. (Daniel Dutro; THM.)

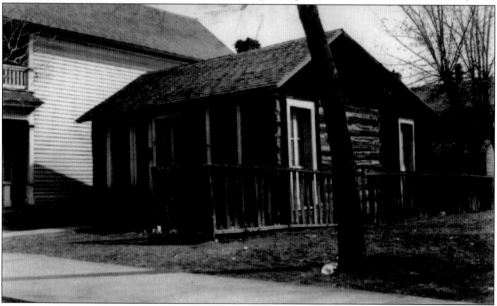

First Home in Great Falls. In the spring of 1884, Fort Benton carpenter Josiah Peeper built this 14-by-20-feet-long fir log cabin on Fifth Avenue South—the first home in Great Falls. In 1890, Vinegar Jones bought the cabin, moved it across the street, built an addition, and lived there for more than a decade when he moved a two-story frame house from his homestead onto the same lot. Jones's two-story house is on the left. (Margaret Ganger.)

VINEGAR JONES. Whitman Gibson Jones, commonly called "Vinegar" for his personality of "spice and vinegar," was born in Maine in 1859 and came to the upper Missouri River in 1880 to build Fort Assiniboine. After four years in Fort Benton, Jones moved to Great Falls Township Company in the late summer of 1884 where he built many of the early buildings. (H. R. Farr; Margaret Ganger.)

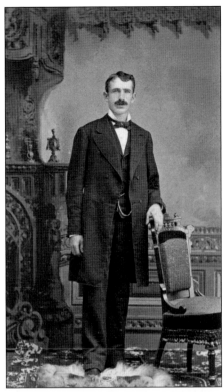

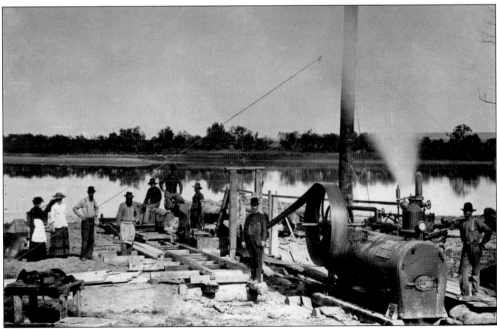

IRA MYERS'S SAWMILL. In the summer of 1884, Ira Myers brought his portable sawmill to the new town of Great Falls and located it on the eastern bank of the Missouri River near the water works. He sawed his first logs on August 8, 1884, which were used for one of the first stores. This photograph, taken in 1885, shows Ira Myers in the center. (THM.)

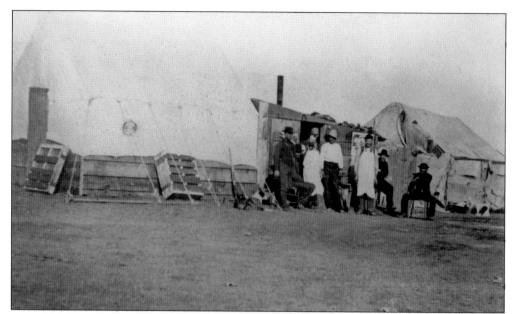

FIRST HOTEL IN GREAT FALLS. In June 1884, James Walker and Thomas G. Carter purchased J. H. Whytal's crude little restaurant and soon opened the first hotel and feed stable, located at about Third Avenue South and Third Street. Made of tents and boards, this small operation served the tiny town until the next year when Walker and Carter moved into a new brick Pioneer Hotel. (Daniel Dutro; THM)

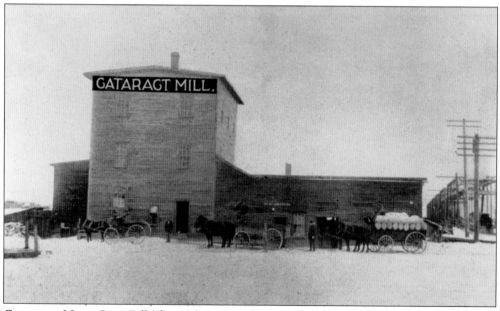

CATARACT MILL. Great Falls' first industry was flour milling, and the first mill was the Cataract Mill. Built by Vinegar Jones during the winter of 1884–85, the Cataract Mill was the scene of the first big social event, a grand ball dedication held on St. Patrick's Day in 1885. After a feast on antelope, dancing continued until sunrise. With miller Richard Graham, the mill became operational in October, just in time to process grain from the new farms of Gibson, Rolfe, and others. (THM.)

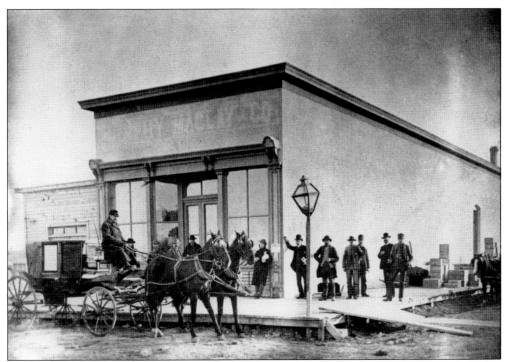

MURPHY-MACLAY HARDWARE. On October 22, 1884, Vinegar Jones completed a building for John T. Murphy and Edgar G. Maclay's store with Worden P. Wren in charge. Murphy-Maclay was the first general store in the tiny town, located at Central Avenue and Second Street. (THM.)

GREAT FALLS TRIBUNE. Will Hanks started the *Sun River Sun* newspaper in 1884 and one year later moved it to Great Falls, publishing the first edition of the *Great Falls Tribune* on May 14, 1885. The first small brick Great Falls Tribune Building is to the right of the Park Hotel. In the early years, the newspaper "boosted" Great Falls, filling its pages with business news, community activities, and promotions for the Democratic Party. (THM.)

First School. Built in the summer of 1885 by Vinegar Jones, this small 20-by-40-feet-long school, located at Third Avenue South and Fifth Street, opened October 12 for about 40 students and hosted the first Christmas celebration. The first teacher, Rev. James Largent, taught during the week and preached on Sunday. (Margaret Ganger.)

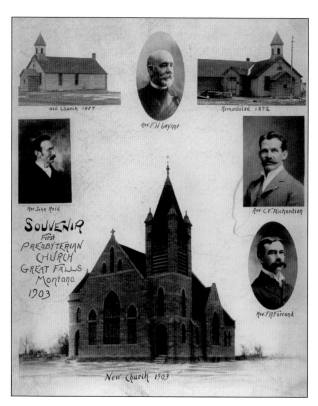

First Church. Until 1887, religious services were held in the schoolhouse. In that year the small Presbyterian congregation built the first church in Great Falls on the corner of First Avenue South and Seventh Street. This church was remodeled in 1892 to keep up with the growing congregation. In 1903, a stone church replaced the wooden building but by 1929 this church was condemned and a new structure was built. (THM.)

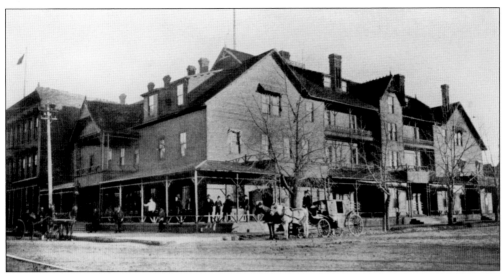

PARK HOTEL. Paris Gibson and H. C. Chowen ordered the Park Hotel built in 1886, originally with 25 rooms that soon expanded to 90. This early hotel featured long piazzas circling the building with views of the Missouri River and relaxing verandas. Among celebrity guests at the Park were Mark Twain, Pavlova, Paderewski, William Howard Taft, Robert La Follette, William Jennings Bryan, and the Fort Shaw Indian School Girls Basketball Team. A fire closed the venerable Park Hotel on July 21, 1914. (THM.)

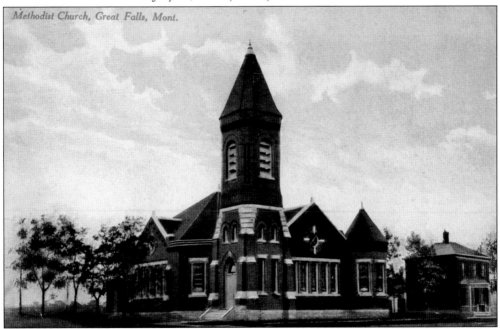

Methodist Church, Great Falls, Mont.

METHODIST CHURCH. Led by circuit riding Rev. William W. Van Orsdel, affectionately known as Brother Van, the first Methodist Church in Great Falls was built in 1888. While this original church has been twice replaced, the historic parsonage built in 1909—which is the longtime home of Brother Van, who is also the superintendent of the Northern Montana Mission—has remained and was added to the National Register of Historic Places as "Brother Van's Residence" in 2003. (Charles E. Morris.)

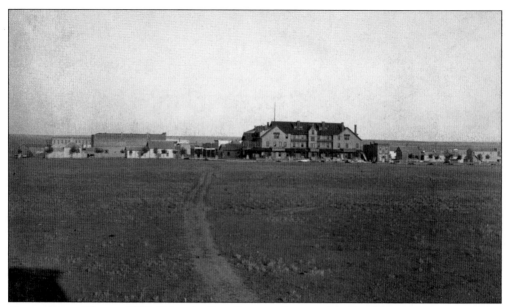

GREAT FALLS TOWN, 1887. Taken by Fort Benton photographer Dan Dutro in June 1887, this image shows the opening on to Central Avenue in the center and the large original Park Hotel on the right with the *Great Falls Tribune* office to the right of the hotel. The first white building on the left is the Townsite Company office built by Vinegar Jones. The trail in the foreground leads from the ford across the Missouri River to the new town.

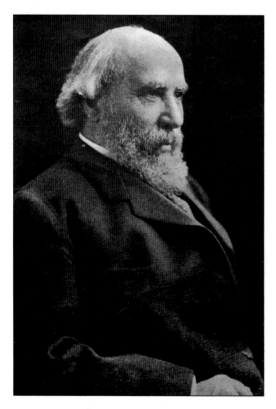

A VISION OF WESTWARD MIGRATION. Minneapolis-based James J. Hill envisioned using his railroad to settle the West. Paris Gibson's plans for Great Falls intrigued Hill, and he paid his first visit in June 1884 to announce that he would extend his St. Paul, Minneapolis & Manitoba Railway there within four years. In later years, Gibson said this marked the actual birth of Great Falls. (THM.)

ST. PAUL, MINNEAPOLIS & MANITOBA RAILWAY.

No. 1440

1887

PASS *E. J. Nally, Esq.*

Chf Clrk. Supt. W U Tel Co

UNTIL DEC. 31ST 1887 UNLESS OTHERWISE ORDERED AND SUBJECT TO CONDITIONS ON BACK WHEN COUNTERSIGNED BY H.C.IVES, ASST GENERAL MANAGER.

COUNTERSIGNED

ASST GEN'L MANAGER.

GENERAL MANAGER.

ST. PAUL, MINNEAPOLIS & MANITOBA RAILWAY. James J. Hill positioned his St. Paul, Minneapolis & Manitoba Railway to build westward from Minot in the Dakota Territory in April 1887. Under leadership of Donald Grant, some 6,600 men and 800 teams pushed westward during the summer of 1887, laying a remarkable 5 or 6 miles of track a day to complete the 700 miles from the Dakotas to Great Falls.

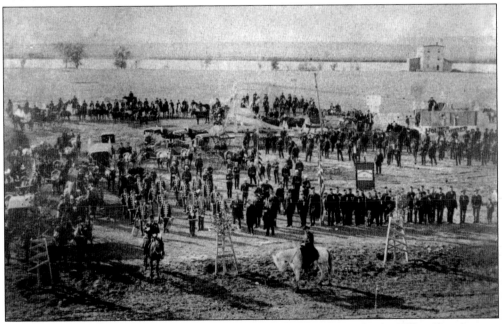

ARRIVAL OF THE RAILROAD. Great Falls followed construction of Jim Hill's railroad across Montana with keen interest. When it became clear that Hill would succeed, the town began to plan a massive celebration. In this picture of the historic day, Saturday, October 15, 1887, almost the entire town of 1,200 turned out to cheer the first steam engine into town. That first train of the St. Paul, Minneapolis & Manitoba Railway arrived loaded with tracklayers, and Great Falls was on its way! (THM.)

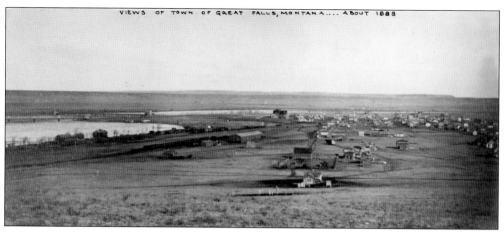

YOUNG GREAT FALLS. This 1888 panoramic view taken from Prospect Hill shows the small town of Great Falls beginning to grow after the arrival of the railroad the previous year. On the left in the distance are the Cataract Mill, the Wagon Bridge, and the Railway Bridge; in the center of town is the large Park Hotel at the head of Central Avenue. (THM.)

ABUNDANT CROPS. Paris Gibson envisioned extensive dryland farming in the fertile soils of Cascade County. He used his land near the new town to showcase the abundant crops that could be grown to supply the new Cataract Mill and later Royal Mill. (THM.)

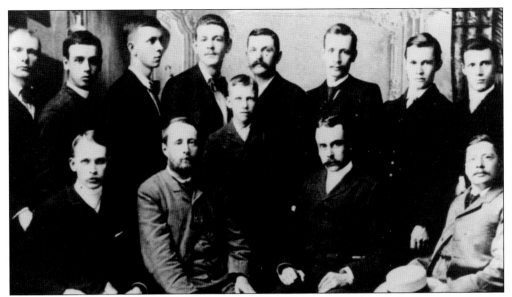

CONSCIENCE OF THE COMMUNITY. Surveyor, lawyer, farmer, and political leader Herbert P. Rolfe was an exceptional leader in the community. On June 16, 1888, Rolfe started the *Great Falls Leader* as an opposition newspaper to the Great Falls Townsite Company and its *Great Falls Tribune*. This image shows Rolfe, second from left in the front, with his talented staff, including future leaders of the rival *Great Falls Tribune* like Oliver S. Warden (front left), Charles Wright (front second right), and William M. Bole (front right). (THM.)

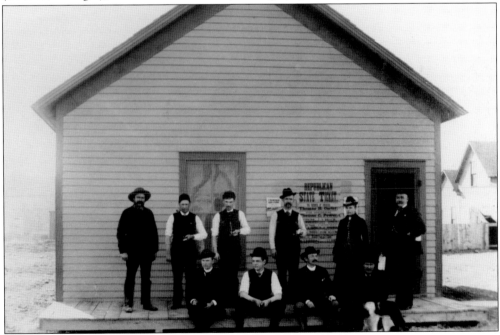

THE LEADER. The *Great Falls Leader* started as a weekly but soon published daily, boosting Great Falls by reporting on business, social and cultural news, and promoting the rights of women, African Americans, and the Republican Party. This image shows the staff of the *Great Falls Leader* posed in front of the newspaper office building. (THM.)

MARTHA EDGERTON ROLFE. In 1863, 13-year-old Martha Edgerton came to Bannack with her father, Sidney Edgerton, who was Montana's first territorial governor. Returning to Montana in 1876 with husband Herbert P. Rolfe, Martha taught and performed music and was active in the women's suffrage movement. Upon the death of her husband in 1895, she became the first female editor of a daily newspaper in Montana, while raising seven small children.

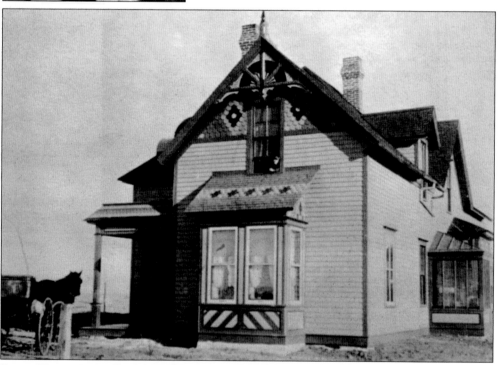

ROLFE HOME. In April 1884, Herbert P. Rolfe built the first frame house of boards and tarpaper on his 160-acre homestead two miles east of the new townsite among the antelope and coyotes. During the summer of 1887, the shack was replaced by a grand 12-room ranch house that stands today at the corner of Third Avenue North and Twenty-sixth Street. This image of the Rolfe home, with one of the Rolfe children peering from the second floor window, was taken about 1890.

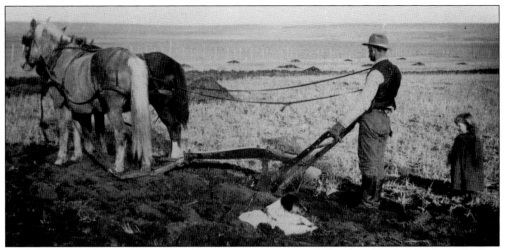

ROLFE HOMESTEAD. Herbert P. Rolfe and other early "city homesteaders" determined to prove the viability of dryland farming. Extensive irrigated and dryland farming in the Sun River Valley and the area around Great Falls was followed by the homestead "boom" of the 1910s. In this February 1889 scene, Tom Mann plows Rolfe's homestead with the help of two horses and Edgerton Rolfe, age three. (THM.)

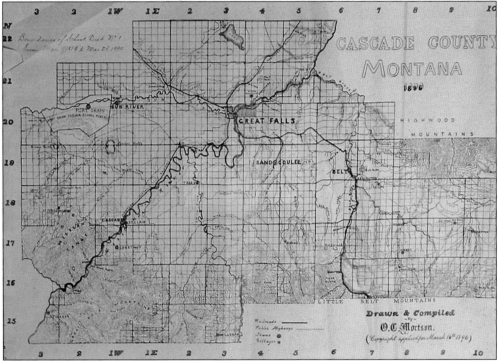

CASCADE COUNTY. In mid-1887, George W. Taylor and Herbert P. Rolfe were sent to Helena to obtain passage of a bill creating Cascade County. After an intense fight in the Montana Territorial Legislature, Cascade County was created, mainly from old Choteau County. On December 21, 1887, the new Cascade County officials were sworn into office, including Bessie Ford, superintendent of schools; George W. Taylor, county attorney; and Herbert P. Rolfe, probate judge. (Great Falls Public Library.)

37

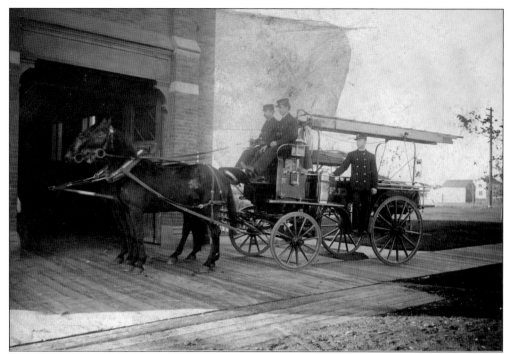

GREAT FALLS FIRE DEPARTMENT. Fire Station No. 1, located at Second Avenue South and Fourth Street, was dedicated Thanksgiving Day 1889. In May 1892, a paid fire department was organized under Chief James Burns. In the spring of 1901, a north side station, shown in this photograph, was built at Fifth Alley North and Thirteenth Street. (THM.)

MCKAY'S BRICKYARD. Brothers William H., James F., and Daniel McKay began making bricks to supply the burgeoning Great Falls market in 1885. Their brickyard was located on Judge George E. Huy's homestead about Sixth Avenue South and Twentieth Street. The piles of rough lumber in the image were used to fire the brick kiln.

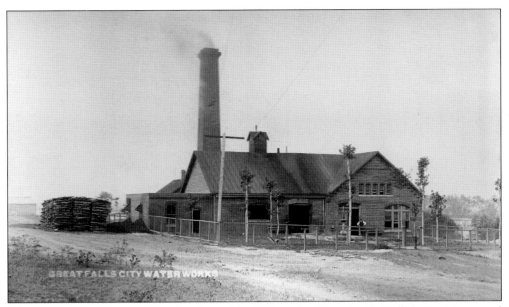

WATER WORKS. The water works, formed in 1889 under Timothy E. Collins, Ira Myers, and Edgar G. Maclay, was located south of the townsite. This image shows the first city water works in the early 1890s.

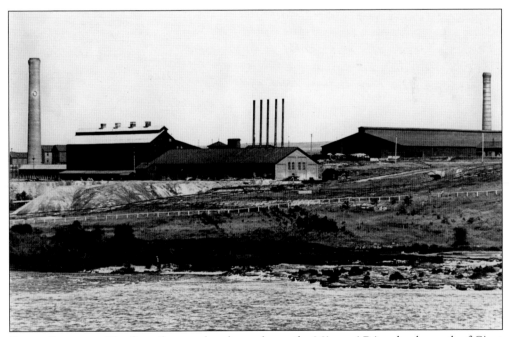

SILVER SMELTER. The first silver smelter, located near the Missouri River banks south of Giant Springs began operations in 1888–1889. Ore of silver and lead, and some gold, was processed at this plant and then shipped east on the new railroad to be refined. The ore came from mining towns Neihart and Barker in the Belt Mountains. (THM.)

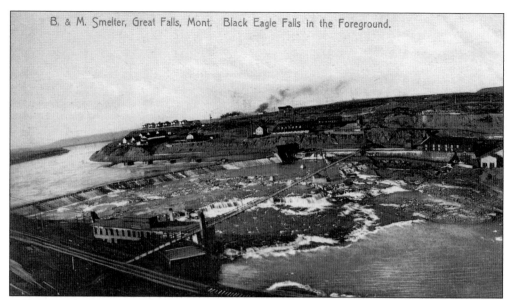

B. & M. Smelter, Great Falls, Mont. Black Eagle Falls in the Foreground.

BLACK EAGLE DAM. Construction of the first dam at Great Falls began in 1889 at Black Eagle. A footbridge was built across the Missouri River for workers to use during the building of the dam and at the new silver smelter and later copper reduction plant on the north bank of the Missouri River at Indian Point. Black Eagle Dam was completed in 1891, the first of five hydroelectric dams across the Missouri River.

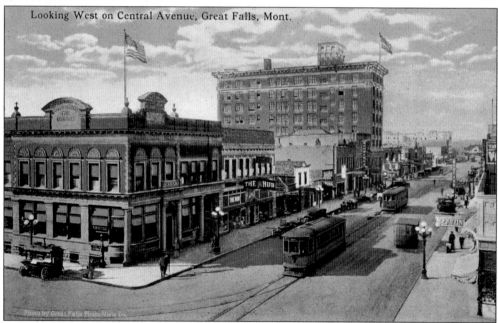

Looking West on Central Avenue, Great Falls, Mont.

STREET RAILWAY. In 1890, the Great Falls Street Railway organized a year before Chicago's "L" streetcars. Great Falls street cars, or trolleys, were first drawn by horses and then by steam engines, called "Dinkies." After completion of the Black Eagle Dam in March 1891, electrical power was available for the street railway. Five routes ran from Central Avenue to the south side, as far as Boston Heights, and the Boston and Montana smelters. Buses replaced the trolley system in November 1931. (Great Falls View Company.)

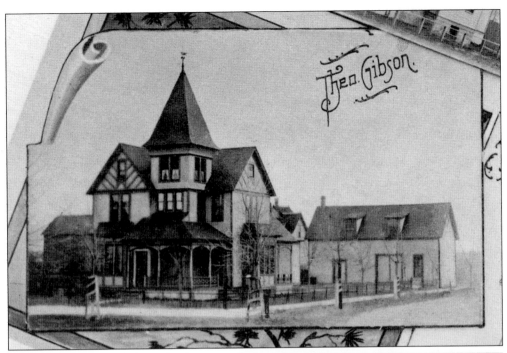

THEODORE GIBSON'S HOME. In the summer of 1890, William Roberts built this fine residence for Paris Gibson's youngest son, Theodore, and his wife, Mary Alice. The home, with its distinctive tower, was located on the city's premier residential boulevard at Fourth Avenue North and Fourth Street. Paris Gibson died there, reportedly in a bedroom on the second floor. Today this historic home has been restored.

ROBERT S. FORD. Born in Kentucky in 1842, Robert S. Ford arrived in Montana Territory in 1864 as a freighting wagon master. In 1871, he brought a large herd of Texas cattle to the Sun River Valley and established one of the largest ranches in northern Montana near Sun River Crossing. Ford moved to Great Falls in 1891 and established the powerful Great Falls National Bank. This image was taken on Ford's 60th birthday, January 14, 1902.

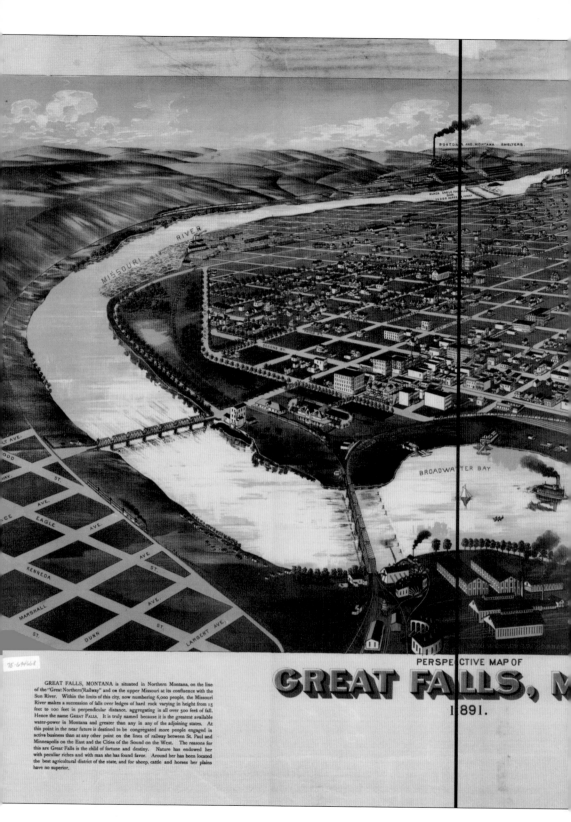

PERSPECTIVE MAP OF

GREAT FALLS, M

1891.

75·6·96668

GREAT FALLS, MONTANA is situated in Northern Montana, on the line of the "Great Northern Railway" and on the upper Missouri at its confluence with the Sun River. Within the limits of this city, now numbering 6,000 people, the Missouri River makes a succession of falls over ledges of hard rock varying in height from 15 feet to 100 feet in perpendicular distance, aggregating in all over 500 feet of fall. Hence the name GREAT FALLS. It is truly named because it is the greatest available water-power in Montana and greater than any in any of the adjoining states. At this point in the near future is destined to be congregated more people engaged in active business than at any other point on the lines of railway between St. Paul and Minneapolis on the East and the Cities of the Sound on the West. The reasons for this are Great Falls is the child of fortune and destiny. Nature has endowed her with peculiar riches and with man she has found favor. Around her has been located the best agricultural district of the state, and for sheep, cattle and horses her plains have no superior.

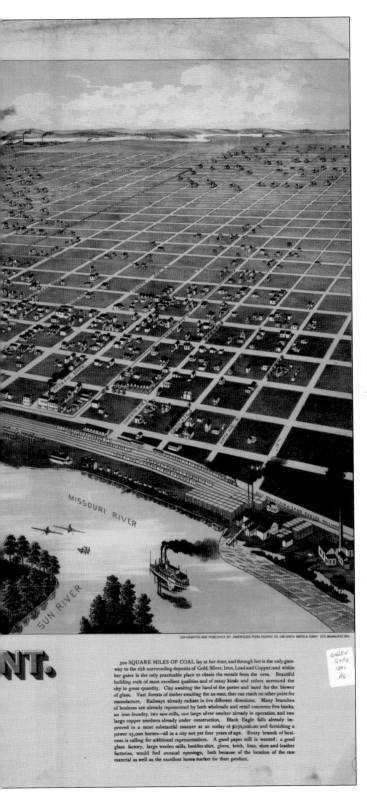

MISSOURI RIVER

SUN RIVER

COPYRIGHTED AND PUBLISHED BY AMERICAN PUBLISHING CO. COR SOUTH WATER & FERRY STS. MILWAUKEE WIS.

NT.

300 SQUARE MILES OF COAL lay at her door, and through her is the only gateway to the rich surrounding deposits of Gold, Silver, Iron, Lead and Copper; and within her gates is the only practicable place to obtain the metals from the ores. Beautiful building rock of most excellent qualities and of many kinds and colors surround the city in great quantity. Clay awaiting the hand of the potter and sand for the blower of glass. Vast forests of timber awaiting the ax-man, that can reach no other point for manufacture. Railways already radiate in five different directions. Many branches of business are already represented by both wholesale and retail concerns; five banks, an iron foundry, two saw-mills, one large silver smelter already in operation, and two large copper smelters already under construction. Black Eagle falls already improved in a most substantial manner at an outlay of $250,000.00 and furnishing a power 25,000 horses—all in a city not yet four years of age. Every branch of business is calling for additional representatives. A good paper mill is wanted; a good glass factory, large woolen mills, besides shirt, glove, brick, lime, shoe and leather factories, would find unusual openings, both because of the location of the raw material as well as the excellent home market for their product.

G4254
.G7A3
1891
.A6

GREAT FALLS PERSPECTIVE MAP. In early 1891, the American Publishing Company presented this grand perspective map of the emerging city of Great Falls, just seven years in existence. The booster map begins with, "Great Falls, Montana is situated in Northern Montana, on the line of the 'Great Northern Railway' and on the upper Missouri at its confluence with the Sun River." Although some structures depicted on this map never materialized, many others did with fine detail on individual buildings and activities such as the Great Northern depot and other rail facilities, silver smelter near Giant Springs, new Boston and Montana smelter across the river on Indian Point, the wagon and railroad bridges, Cataract Mill, schools, churches, Broadwater Bay, the Missouri and Sun Rivers, and small steamboats on the river. The map boosts the economic potential in agriculture and mineral resources, urging the growth of new industries.

43

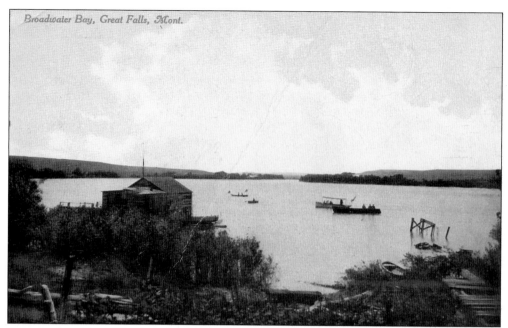

Broadwater Bay, Great Falls, Mont.

BROADWATER BAY. The city of Great Falls is located on a beautiful and picturesque bend of the Missouri River, just below its confluence with Sun River, where the foot of Long Pool widens to form lake-like Broadwater Bay. This bay presented an early playground with a boathouse for swimmers and boaters.

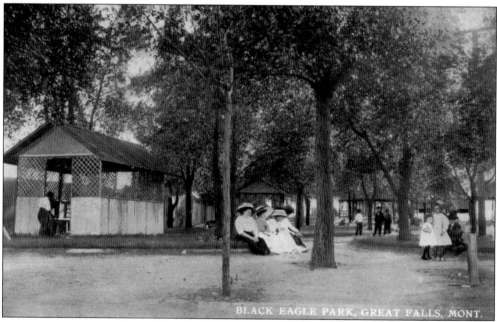

BLACK EAGLE PARK, GREAT FALLS, MONT.

BLACK EAGLE PARK. The first Black Eagle Park was a popular park located on the south side of the Missouri River opposite Black Eagle Falls and owned by the Street Railway Company. This park was the site of early Cascade County fairs and encampments by cavalry troops from Fort Assiniboine. In 1911, the city took over, enlarged and irrigated the park and added an athletic field for baseball. Today's Centene Baseball Park is on this site.

44

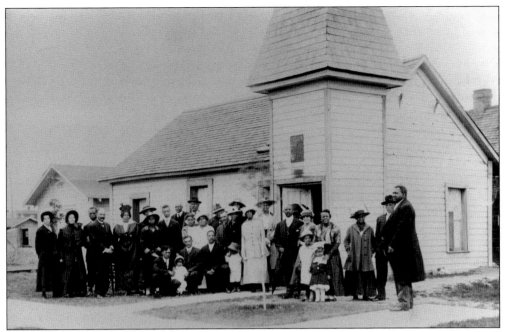

AFRICAN METHODIST EPISCOPAL (A.M.E.) CHURCH. African Americans were de facto segregated in the lower south side of Great Falls. African American women were the soul, and the African Methodist Episcopal Church was the heart of the early African American community. By 1890, church services were held in the first fire station. The following year, the cornerstone was laid for a wood frame church, opened in July 1891, at 916 Fifth Avenue South. (Union Bethel A.M.E. Church.)

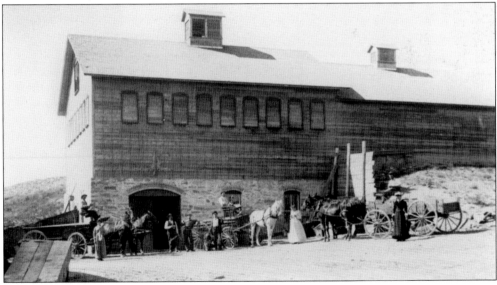

VOLK'S BREWERY. Volk's Brewery was the original brewing plant in Great Falls. Located on Upper River Road south of Great Falls at today's Verde Park, Nicholas and Christian Volk Sr. opened their brewery in 1891. The brewery wagons delivered beer to thirsty workers throughout the region. Built of wood and stone, the upper wood portion of the brewery burned in 1894, then was rebuilt and continued until Prohibition in 1919. (THM.)

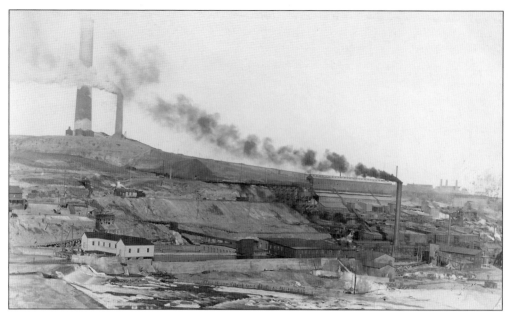

FROM BOSTON AND MONTANA TO ANACONDA. Construction of the original 167-foot stack at the Boston and Montana Smelter was completed July 4, 1891. Located on Indian Point overlooking Black Eagle Falls, the original copper reduction plant soon opened for business. A second, much larger 506-foot stack was built and began operations in June 1909; it was the highest in the world. The two stacks stood side by side until 1915. The big stack was blasted down in 1982 when Anaconda Copper Company closed operations, removing Great Falls' signature landmark. (Tom Mulvaney.)

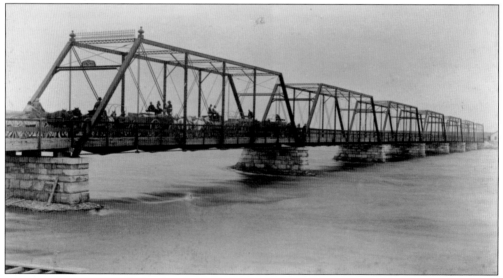

FIRST AVENUE WAGON BRIDGE. Wheeler O. Dexter put a ferry in service across the Missouri River at Great Falls in November 1885. In June 1888, the San Francisco Bridge Company, under engineer J. C. Chesborough, completed a wagon bridge across the Missouri River replacing the ferry. The 1,000-foot-long steel bridge connected First Avenue North with Central Avenue on the west side of the Missouri River. This bridge operated as a toll bridge until 1891 and continued to serve until the present bridge opened November 30, 1920. (THM.)

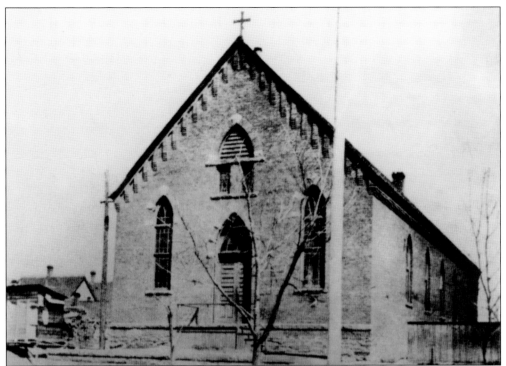

FIRST PARISH CHURCH. The first Roman Catholic church in Great Falls, St. Ann's, was erected just north of the present Cathedral of St. Ann in 1890. It was constructed of hand-cut stone quarried south of Great Falls. The first pastor was Father Dols. Cavalry Catholic Cemetery was established the same year. The Diocese of Eastern Montana was created by papal decree of Pope Pious X on May 18, 1904, with Most Reverend Mathias Lenihan the first Bishop of Great Falls. (THM.)

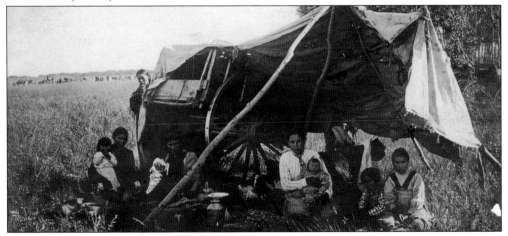

FIRST INDIAN ENCAMPMENT. Great Falls attracted reservation-less Native Americans, many of them Cree under Chief Little Bear, and Metis refuges from Canada with their Red River carts. In June 1896, Lt. John J. Pershing arrived from Fort Assiniboine with African American U.S. 10th Cavalry Regiment troopers to deport the Crees. Some 96 were rounded up, a court battle was fought and lost, and the Crees deported to Canada, except one who had served many years as a U.S. government scout.

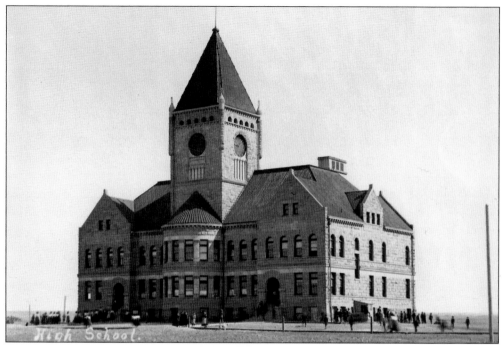

CENTRAL HIGH SCHOOL. The first official high school in Great Falls, Central High School was completed in 1896 with 20 rooms. Located at First Avenue North and Sixteenth Street on a sloping hill, Dan McKay and Brothers contractors used local sandstone. In 1930 a new million-dollar Great Falls High School was built, and the old school became Paris Gibson Junior High School. Today this stately structure, without its tower, operates as Paris Gibson Square Museum of Art.

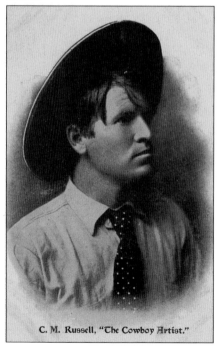

C. M. Russell, "The Cowboy Artist."

YOUNG COWBOY ARTIST. Young Charles M. "Kid" Russell arrived in Montana Territory in April 1880 and learned cowboy life in the Judith Basin. Russell spent much of the 1890s in Cascade, earned a reputation as the "cowboy artist," and married Nancy B. Mann in 1896. The newlyweds moved to Great Falls the next year where Charles's artistic talent and Nancy's business sense led to international fame. Their home, Russell's Studio Cabin, and the Charles M. Russell Museum are open to the public today.

Three

SHAPING THE CITY
THE GOOD YEARS

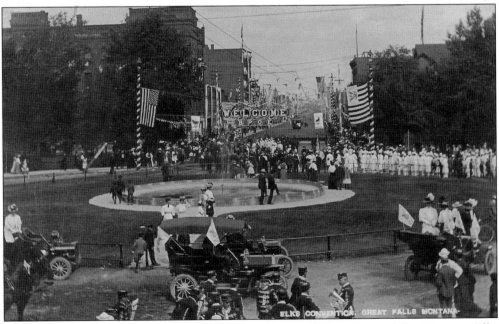

WELCOME TO GREAT FALLS. Great Falls, just 24 years old, welcomed the Montana Elks Convention as Elks members paraded down Central Avenue on August 13, 1908. The new city put on its glad rags to greet more than 1,000 members of the Benevolent and Protective Order of Elks from all over Montana. Charles M. Russell joined the Great Falls Elks lodge that year, and four years later he gave the lodge one of his finest oil paintings, *The Exalted Ruler,* a noble elk from Montana's mountain country. (Great Falls Photo and View Company)

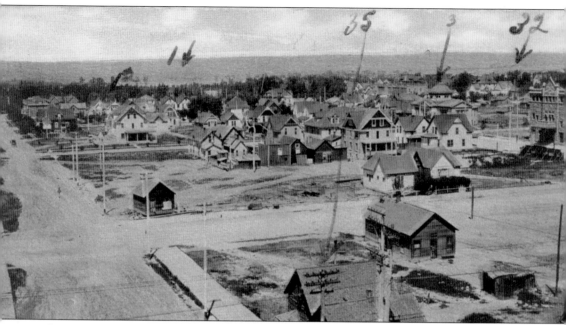

GREAT FALLS PANORAMA 1–2, 1910. These two (of eight) panoramic postcards were taken in 1910 from the top of the Tod Block. Numbers mark key locations. On the left half of this card are the following landmarks: No. 2, city park; No. 1, High Plateau; No. 35, unidentified; No. 3, public library; and No. 32, Little Chicago. On the right half are the following landmarks:

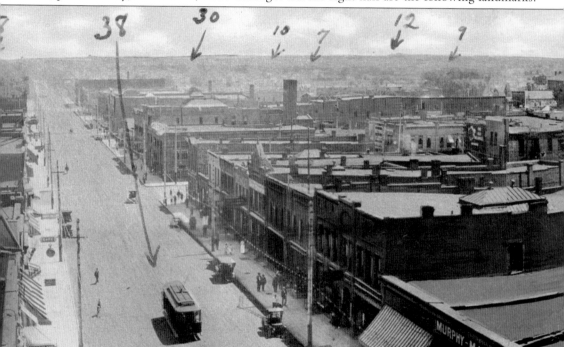

GREAT FALLS PANORAMA 3–4, 1910. On the left side of this card are the following landmarks: No. 8, Central High School; No. 38, south side streetcar on Central Avenue; No. 30, Boston Heights; No. 10, Kranz Greenhouse; No. 7, Presbyterian church; No. 12, Highwood Mountains; and No.

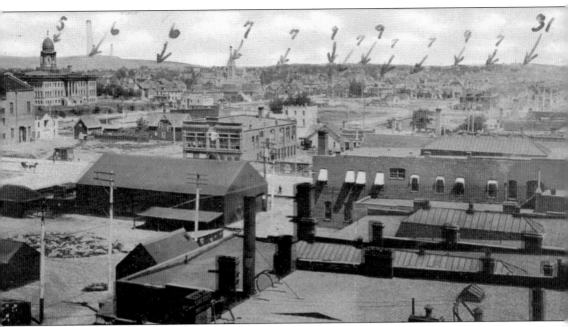

No. 4, Grand Opera House; No. 5, Cascade County Courthouse; No. 6, Boston and Montana smelter; No. 7 St. Ann's Cathedral; unmarked in front of St. Ann's is the Rainbow Hotel under construction; No. 9, grade schools; and No. 31, Black Eagle Park. (Charles E. Morris; THM.)

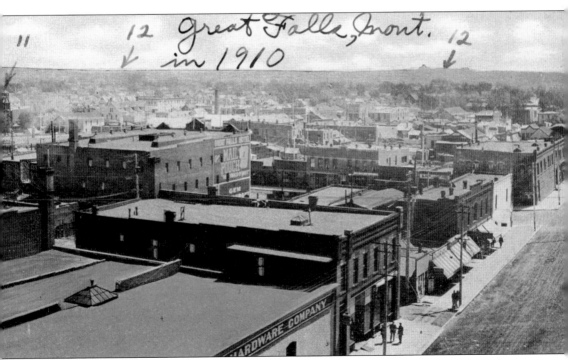

9, grade school. On the right half are the following landmarks: No. 11, fire department; and No. 12, the Little Belt Mountains and the Belt Mountain Range. (Charles E. Morris; THM.)

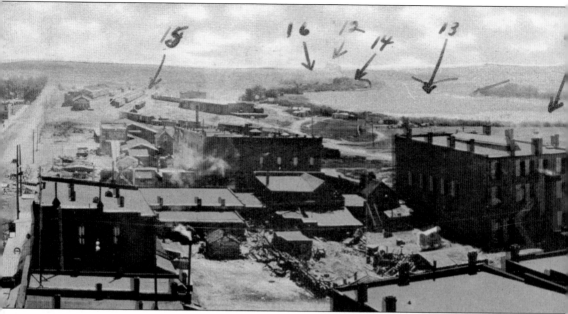

GREAT FALLS PANORAMA 5–6, 1910. These two (of eight) postcards continue the panoramic view of Great Falls taken in 1910. Pictured on the left half of this card are the following landmarks: No. 15, Burlington Railroad; No. 16, a pretty picture spot for writer's greenhouse near the Missouri River; No. 12, the Belt Mountains; No. 14, city water pumping station; No. 13, the Missouri River and Park Island; and No. 23, the Missouri River. On the right half are

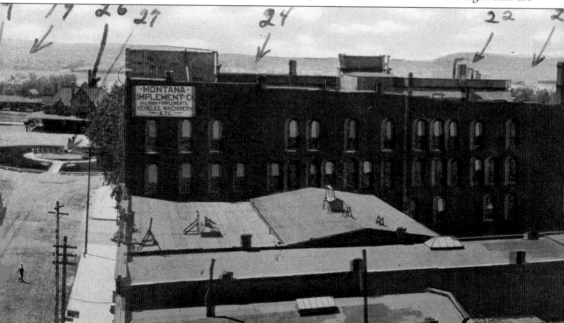

GREAT FALLS PANORAMA 7–8, 1910. Pictured on the left are the following landmarks: No. 39, electric streetcar serving the Boston and Montana smelter, Black Eagle Park, Boston Heights, and the south side; No. 19, west Great Falls; No. 26, old union depot serving the Great Northern Railroad; No. 27, Circle Park and fountain; No. 24, west Great Falls school; No. 22, Great Falls

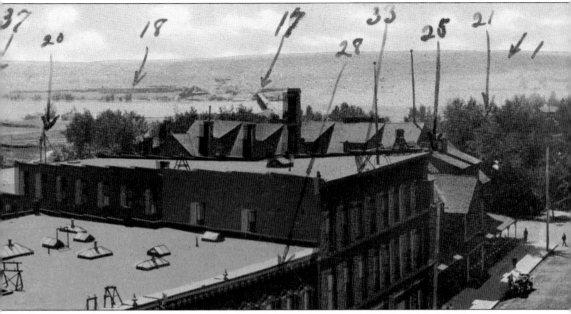

the following landmarks: No. 37, west side greenhouses; No. 20, spot where the new union depot is to be built; No. 18, the Great Northern Railroad roundhouse; No. 17, West Great Falls (formerly Johnstown); No. 28, post office; No. 33, U.S. customs office; No. 25, Park Hotel; No. 21, public park; and No. 1, Western High Plateau (Gore Hill). (Charles E. Morris; THM.)

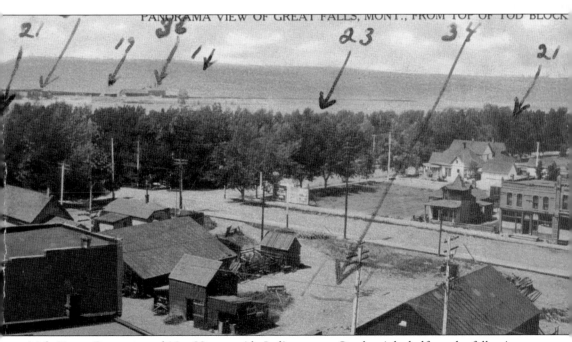

Malt House Brewery; and No. 29, west side Indian camp. On the right half are the following landmarks: No. 21, Great Falls Park (later Gibson Park); No. 36, flour mill; No. 19, west Great Falls; No. 1, High Plateau; No. 23, the Missouri River; No. 34, where the new post office was to be built; and No. 21, public park. (Charles E. Morris; THM.)

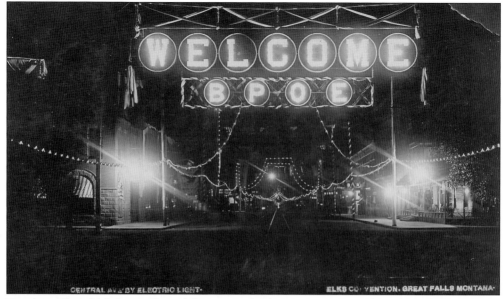

CENTRAL AVENUE BY ELECTRIC LIGHT. ELKS CONVENTION. GREAT FALLS MONTANA.

ELECTRIC CITY. Lighting on Central Avenue was in place to greet visitors from throughout Montana when they visited for the Elks Convention in 1908. Purple and white banners and bunting decorated the buildings to welcome visitors. With abundant power from the Black Eagle Dam and a dam at Rainbow Falls in the planning, Great Falls was earning its reputation as the "Electric City."

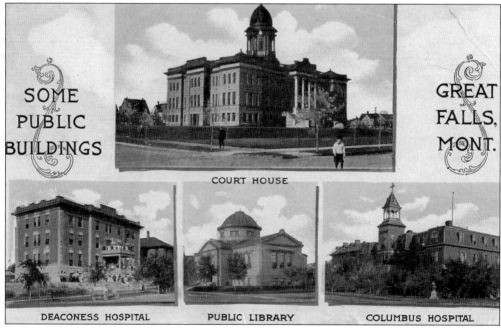

SOME PUBLIC BUILDINGS

GREAT FALLS, MONT.

COURT HOUSE

DEACONESS HOSPITAL PUBLIC LIBRARY COLUMBUS HOSPITAL

MONTANA DEACONESS HOSPITAL. Brother Van spearheaded the effort to build a Protestant hospital in Great Falls, the first Deaconess hospital in Montana. The Montana Deaconess Hospital, built by contractor Joseph Wagner, opened June 16, 1898 with Brother Van as its president. Earlier in 1894 the Columbus Hospital opened under the Sisters of Charity of Providence. The image shows Cascade County Courthouse completed in 1902 (upper); Montana Deaconess Hospital (lower left); Carnegie Library (lower center); and Columbus Hospital (lower right).

54

LANDLESS INDIANS. From its founding, Great Falls became "home" for wandering Native Americans, many of them Turtle Mountain Chippewa, Red River Cree, and mixed race Metis. Camp locations changed over time with the earliest located near the mouth of the Sun River. Over the years, these landless Indians camped on the west bank of the Missouri, Hill 57, Mount Royal, and Wire Mill Road. (THM.)

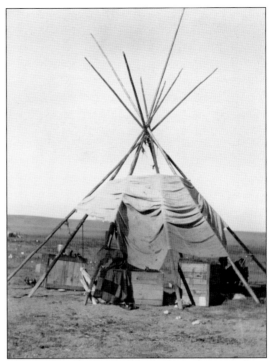

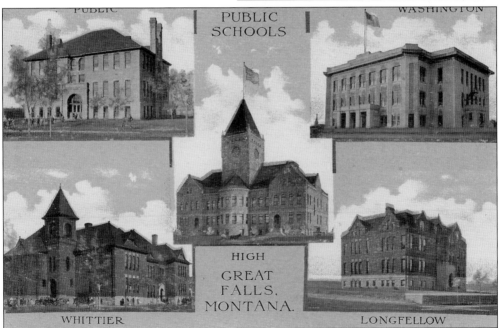

EARLY PUBLIC SCHOOLS. When Samuel D. Largent became superintendent in 1892, Great Falls' educational system was composed of two school buildings: Whittier and Longfellow. Whittier (lower left) on the north side opened on the poet John Greenleaf Whittier's birthday, December 17, 1890. Lincoln (upper left) was built in 1902. Washington (upper right) on the north side opened in 1910, Longfellow (lower right) on the south side opened in 1891, and Central High School (center) opened in 1897.

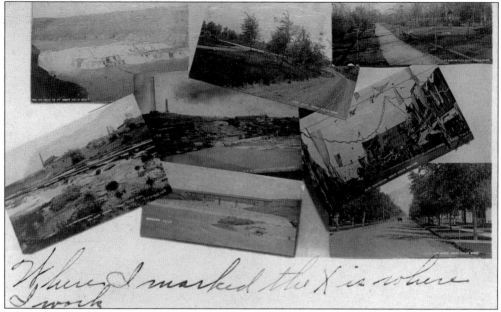

GREAT FALLS PRETTY SCENES. This 1909 montage shows scenes around Great Falls, including (clockwise from lower left) Giant Springs with the silver smelter; Great Falls of the Missouri River; River Drive; Gibson Park; Elks 1908 Convention; Fourth Avenue residences; Rainbow Falls; and center Black Eagle Falls with the Boston and Montana Smelter. The sender marked an X on the business where he worked, writing to his girlfriend, Jennie Mclain, "There are a lot of pretty scenes in Great Falls wish we could take some in next Sunday." (Great Falls Photo and View Company.)

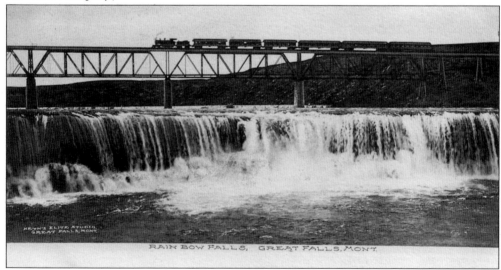

NIAGARA OF THE WEST. The potential for the development of waterpower along the falls of the Missouri River led to the founding of Great Falls. Three major dams, Black Eagle Dam and Falls, Volta Dam (later named Ryan Dam) at the Great Falls, and Rainbow Dam and Falls, supported the claim on the back of this postcard that "Power developed in these plants serves the greatest inland empire in America." This *c.* 1908 image shows a Great Northern train crossing Rainbow Falls. (Heyn's Elite Studio.)

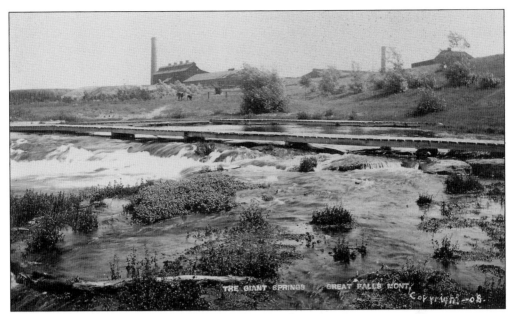

GIANT SPRINGS. Giant Springs, located below Black Eagle Falls, is one of the world's largest springs. The spring water originates in the Little Belt Mountains, 75 miles away, traveling for 2,900 years before escaping the Madison aquifer. The spring outlet discharges an incredible 193 million gallons of water each day to form the world's shortest river, Roe River. A popular tourist destination since the visit of Lewis and Clark in 1805, Giant Springs is now a state park. This early image shows the silver smelter in the background. (Andrew Finch.)

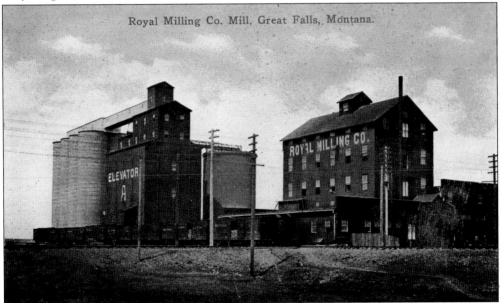

ROYAL MILLS. While the Cataract Mill was the first in Great Falls, in 1893 the Royal Milling Company opened for business. After 1910, homesteading and wheat growing exploded in Cascade County, and in 1916 Royal Milling built the modern, larger mill shown in this scene. Over the years the company proved to be a highly successful operation, and in 1928 Royal Milling merged with the nationally prominent General Mills.

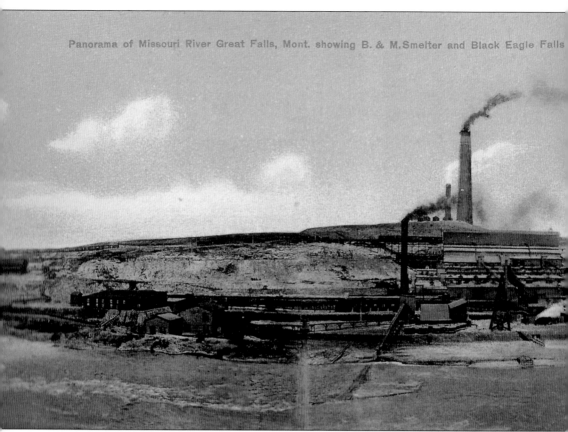

BOSTON AND MONTANA SMELTERS. This panoramic view shows the combination that powered the industrial rise of Great Falls—the Missouri River, Black Eagle Dam, and the Boston and Montana smelter. Growth of the silver smelting operation and later concentrator, refinery, electrolyte house, wire mill, and other operations fed the demand for brick and steel, keeping local brick works and Great Falls Iron Works in business. As Boston and Montana expanded,

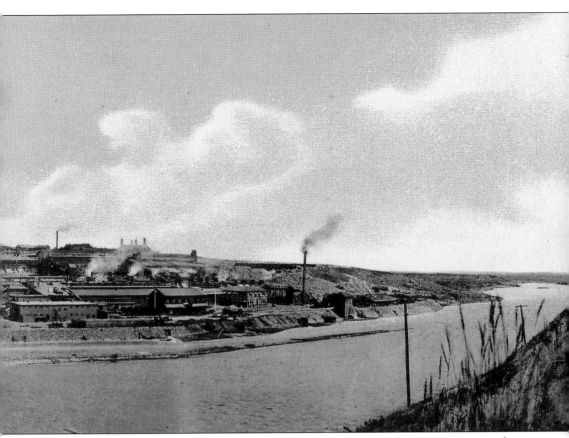

employment rose to about 1,000 men by 1900. In 1908, construction began on a new smelter and in 1910 Anaconda Copper Company bought the Boston and Montana Smelter. Operations continued in Great Falls for 70 more years and through the years, many immigrants went to work for the company with towns like Little Chicago, later Black Eagle, filled with a broad ethnic mix. (Great Falls Photo and View Company.)

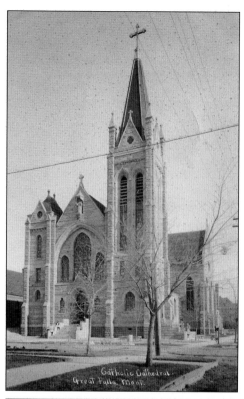

ST. ANN'S CATHEDRAL. Southern and Central European immigrants brought many Roman Catholics to Great Falls. The first bishop, Matthias Lenihan, hired architect John Hackett Kent to design a cathedral equivalent to those in Europe. St. Ann's Cathedral, a grand sandstone building at Third Avenue North and Seventh Street, was the result. Dedicated on Sunday, December 15, 1907, St. Ann's underwent extensive restoration in 2003–2004. (Thomas Mulvaney.)

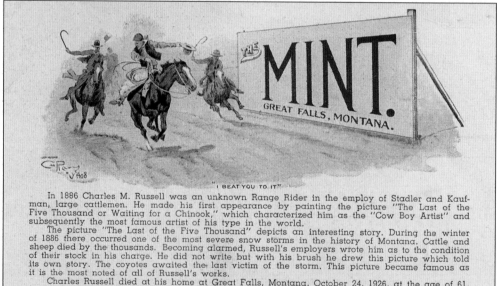

"I BEAT YOU TO IT"

In 1886 Charles M. Russell was an unknown Range Rider in the employ of Stadler and Kaufman, large cattlemen. He made his first appearance by painting the picture "The Last of the Five Thousand or Waiting for a Chinook," which characterized him as the "Cow Boy Artist" and subsequently the most famous artist of his type in the world.

The picture "The Last of the Five Thousand" depicts an interesting story. During the winter of 1886 there occurred one of the most severe snow storms in the history of Montana. Cattle and sheep died by the thousands. Becoming alarmed, Russell's employers wrote him as to the condition of their stock in his charge. He did not write but with his brush he drew this picture which told its own story. The coyotes awaited the last victim of the storm. This picture became famous as it is the most noted of all of Russell's works.

Charles Russell died at his home at Great Falls, Montana, October 24, 1926, at the age of 61.

THE MINT. On the night of April 13, 1898, D. C. Dulin opened The Mint saloon, filled with solid mahogany and paneled with plate-glass mirrors. Cowpunchers riding in from the range to the Mint often found Charlie Russell wetting his whistle and telling his stories there. The Mint, its foremost early patron, Charles M. Russell, and its later proprietor, Sid Willis, became Great Falls institutions.

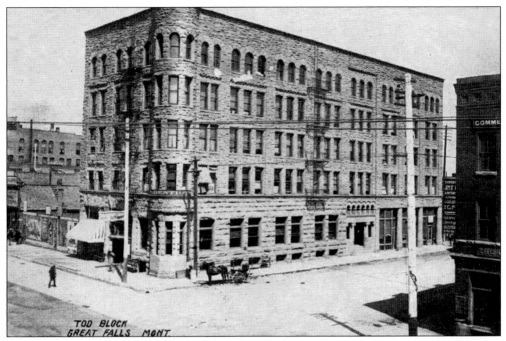

TOD BLOCK. One of the great early stone buildings at the corner of Central Avenue and Second Street, the Tod Block, built by J. Steward Tod in 1890, housed the Stanton Bank. A fire destroyed the Tod Block in December 1928, together with the adjoining Charteris building and the Jewell Block. A priceless collection of paintings of Charles M. Russell, woodcarvings of Blackfeet artist John L. Clarke, and artwork of Charles Beil were destroyed in the fire.

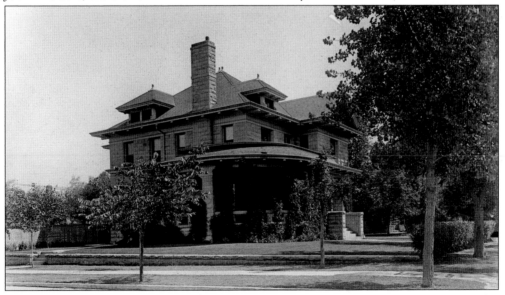

FORD–BOVEY HOME. Designed by architect Harry A. Black and constructed in May 1908, this period revival vernacular residence was built for Lee M. Ford, son of Robert S. Ford. The walls and foundation were coursed ashlars sandstone locally quarried. This home, at Fourth Avenue North and Fourth Street is one of the anchors in the north side residential district, which showcases the fine residential homes on Fourth Avenue North. (THM.)

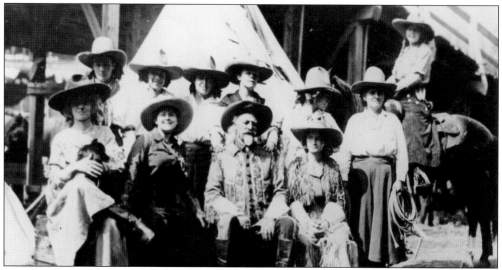

BUFFALO BILL. Shonkin rancher Milton E. Milner knew Col. William F. Cody and promoter Nate Salisbury, who both invested in the Milner ranch. Milner suggested that they form a "Wild West" show, and this became the Buffalo Bill Wild West Show. The show visited Great Falls in 1913. A star bronco buster performer was local girl Fanny Sperry Steele (pictured in front right of Buffalo Bill), who in 2009 was inducted into the Montana Cowboy Hall of Fame. (THM.)

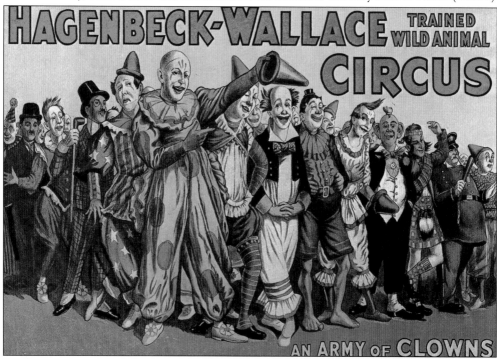

CIRCUS IN TOWN. A highlight for children was always the arrival of the circus in town. On August 6, 1914, the Sells-Floto Circus came to Great Falls featuring Buffalo Bill's Warpath Spectacle. Sells-Floto brought 600 performers, 450 horses, 40 clowns, 120 champion riders, three herds of elephants, and nine bands, to parade down Central Avenue and then perform in tents covering 11 acres.

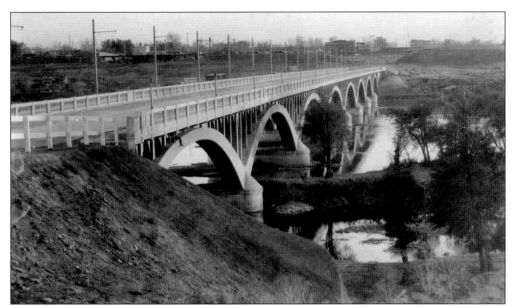

TENTH STREET BRIDGE. Built in 1920, the Tenth Street Bridge is the longest open-spandrel, ribbed-arch, concrete bridge in Montana. Commissioned by Paris Gibson, structural engineer Ralph Adams designed it with architect George H. Shanley. In the words of Arlene Reichert, "The Historic Tenth Street Bridge is an elegant symbol of Montana's past." The National Trust for Historic Preservation named the Tenth Street Bridge as one of 50 historic "treasures" worth saving.

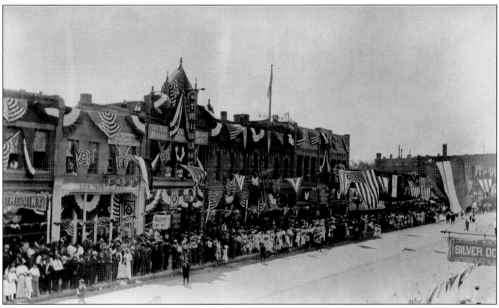

GOLDEN JUBILEE. Montana celebrated its Territorial Golden Jubilee in August 1914, and Great Falls had a memorable parade to mark the occasion. Buildings were covered with banners, flags, and bunting. The 200 block of Central Avenue was packed with spectators in front of the Mint Saloon, the Great Falls Tribune Building, and across Central Avenue to the Silver Dollar Saloon. (THM.)

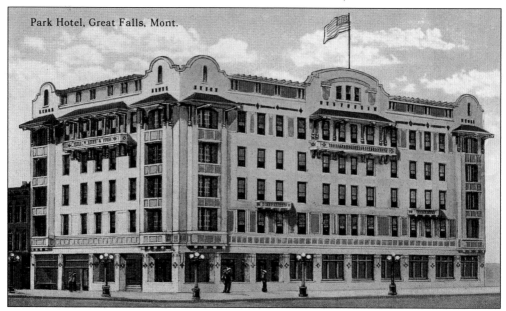

Park Hotel, Great Falls, Mont.

NEW PARK HOTEL. After a fire in 1914, the original Park Hotel at 100 Central Avenue was razed in 1915 and a new Park Hotel, designed by architect George H. Shanley in a Spanish Mission style, was built by contractors Henning S. Leigland and Michael S. Kleppe and opened January 15, 1916. Today it serves quietly as the Downtowner, a retirement community.

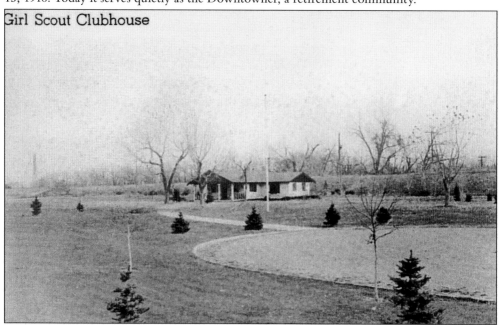

Girl Scout Clubhouse

GIRL SCOUT CLUBHOUSE. The Girl Scouts of America started nationally in 1912 and began operations in Great Falls in 1919–1920. The Works Progress Administration (WPA) built the Playhouse, shown in this scene, for the Girl Scouts in early 1937. Today the old railroad track bed behind the Playhouse serves the Burlington Northern Railroad. The Playhouse has been preserved, although the Riverside Railyard Skate Park now stands beside it and overshadows it. (HPAC.)

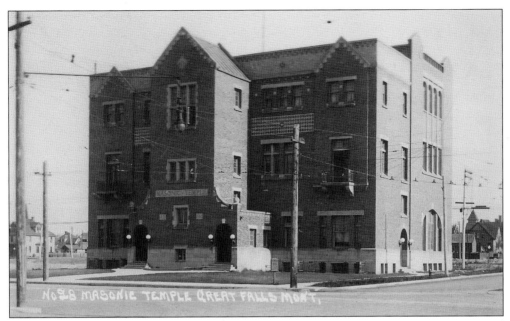

MASONIC TEMPLE. The cornerstone was laid in June 1914 for a new Masonic temple. Designed by architect William R. Mowery and built by Alex Mowbray, the impressive new temple at 827 Central Avenue was dedicated on September 15, 1914, in the presence of 1,000 Montana Grand Lodge Masons. On the second floor of this temple, Hugh C. Sutherland, adviser and "Dad," guided the Order of DeMolay boys from 1925 to 1969 and led the Great Falls chapter to become the world's largest. (Tom Mulvaney.)

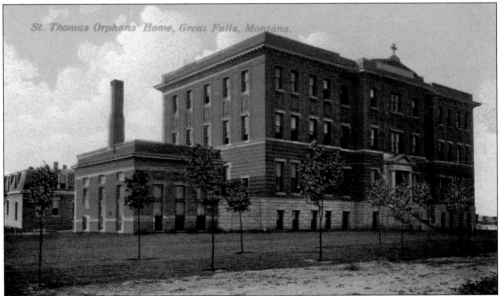

ST. THOMAS. St. Thomas Orphans' Home formally opened on February 22, 1911, under the Sisters of Charity of Providence. Built by James H. Donlin, Christopher Fontana, Frank Coombs, and Thomas C. King, the great brick and stone structure faced Central Avenue at Thirty-second Street. By 1980, this orphanage and boarding school had been home for 4,483 children before it was demolished in 1983. (THM.)

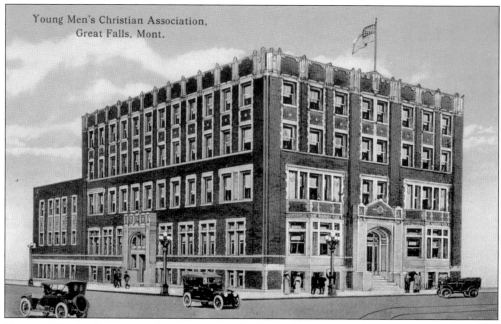

YOUNG MEN'S CHRISTIAN ASSOCIATION. In June 1914, a campaign began to raise public funds to build the first Young Men's Christian Association (YMCA) in Great Falls. Twenty months later, this four-story building at First Avenue North and Park Drive was opened in February 1916. Designed by architect George H. Shanley and built by Lange Engineering and Construction, the new YMCA had a gymnasium, swimming pool, dormitory, and game rooms. It was added to the National Register of Historic Places in 1986 but was torn down that same year. (Charles E. Morris.)

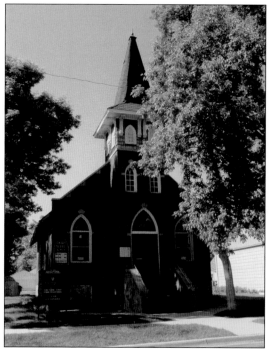

UNION BETHEL A.M.E. CHURCH. By 1916, the original A.M.E. church had deteriorated and was replaced in 1917 by a Gothic style, wood-frame, brick veneer edifice. Union Bethel African Methodist Episcopal Church served as the religious, social, and cultural center of the African American community. Today the church has a multiracial congregation. In 2003, this historic church was added to the National Register of Historic Places. (Ken Robison.)

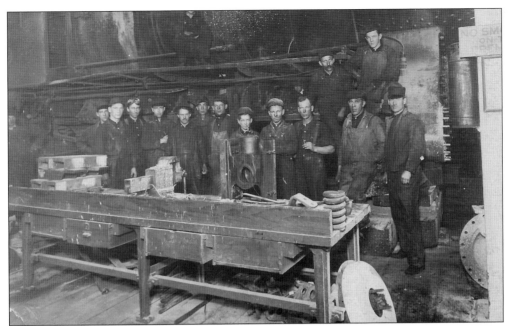

It's All about Workers. By the early 1890s, Great Falls was becoming a major rail center serving the St. Paul, Minneapolis & Manitoba Railway (later the Great Northern Railway), Montana Central Rail, Great Falls & Canada Railway, Belt Mountain Railway, and Sand Coulee-Stockett line. With these train systems came major rail shops and repair yards and hundreds of jobs for workers.

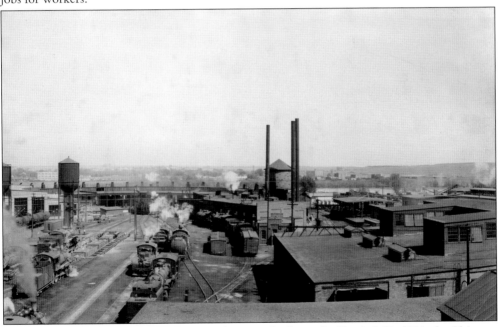

Railroads Ruled. Aviation was in its infancy, and rail travel still ruled. By 1914, the Chicago, Milwaukee, St. Paul and Pacific Railroad also operated through Great Falls. During World War I, women began replacing men in many jobs, including working on steam engines in the roundhouse at the Great Northern Railway repair yards in Great Falls.

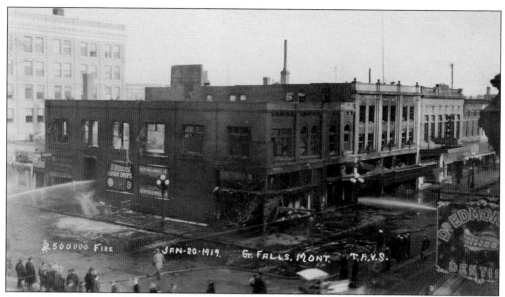

PARIS DRY GOODS FIRE. A fire at the Paris Dry Goods Store on January 20, 1919, was the worst ever suffered in Great Falls. Central Avenue was filled with spectators watching fire chief Alfred J. Trodick and his men battle the blaze. The conflagration gutted the Paris Dry Goods Store and adjacent buildings at 301–307 Central Avenue causing more than $500,000 in damage. The Paris rebuilt a new store at the other end of the 300 Block. (Tom Mulvaney.)

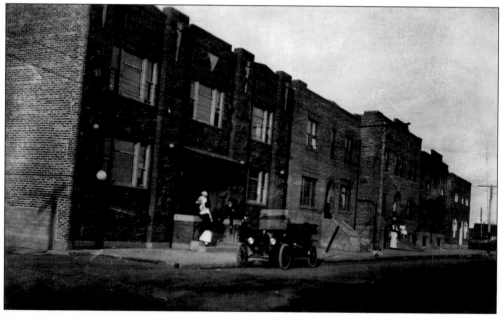

TENTH ALLEY SOUTH. Prostitution in Great Falls was centered in the lower south side under several influential "madams" in places like Rosebud Alley. With the arrival of the Milwaukee Railroad, this area was transformed into railroad warehouses. In exchange, in 1913 the "madams" were provided with the brick buildings shown in this scene at Tenth Alley South and Second Street. (Cascade County Commission.)

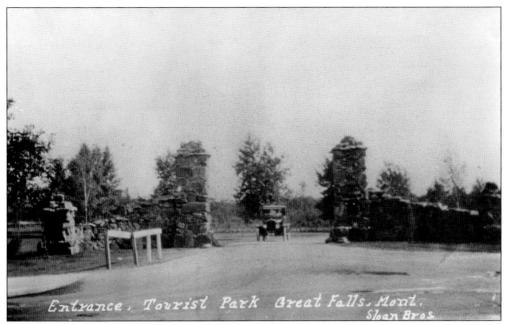

TOURIST PARK. By 1910, automobiles began to replace horses, which resulted in demands for improved roads and touring facilities. Great Falls responded by clearing out old Cataract Mill to build a tourist park along the Missouri River. Within the ornate stone entrance, built by the Great Falls Automobile Association in 1921, travelers could park their cars and stay in cabins or tents.

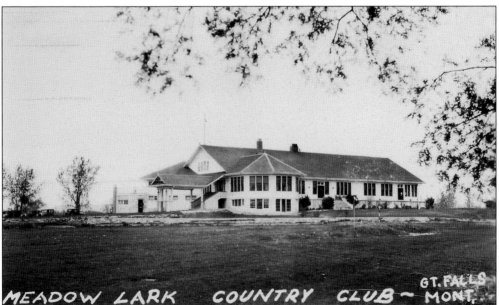

MEADOW LARK COUNTRY CLUB. Founded in 1919 at the confluence of the Missouri and Sun Rivers, the Meadow Lark Country Club featured a large main clubhouse. City leaders proclaimed the opening of this private venue. The club pioneered Montana golf with a classic course along the Missouri River that was played by heavyweight champion Jack Dempsey during his six-week-long training camp at Great Falls.

VINEGAR JONES CABIN. Vinegar Jones knew the importance of his cabin as the city's "first home," and until his death in 1931 preserved and protected it. The cabin survived the elements, fires, and demolition permits. In 2001, Mark Blom donated the cabin to the city, and the Historic Preservation Advisory Commission worked to save and restore it. With help from a broad coalition, the cabin, the only structure remaining from 1884, was saved and stands proudly in Gibson Park. (Ken Robison.)

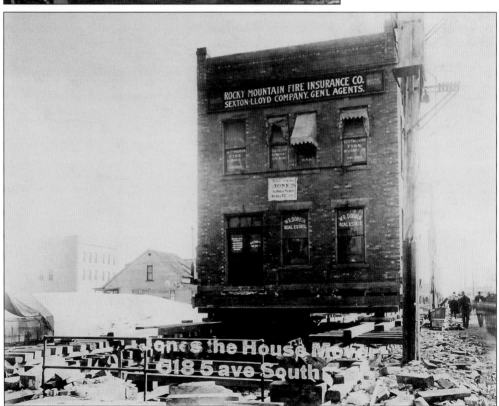

JONES THE HOUSE MOVER. Always busy, Vinegar Jones found time to homestead southwest of Great Falls and ranch near Birdtail Rock on the Old Mullan Road. As a house mover Jones had no peer, and it was said that if a building was moved the mover was likely to be "ole Jones." Here Jones moves the first Rocky Mountain Fire Insurance building in 1912. (Margaret Ganger.)

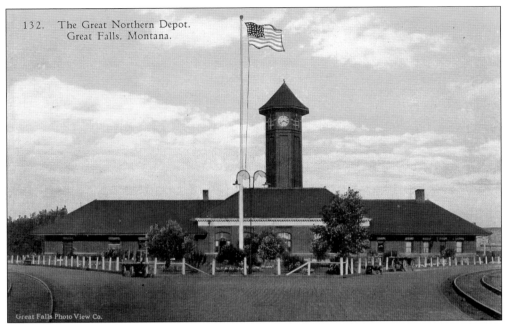

132. The Great Northern Depot.
Great Falls, Montana.

Great Falls Photo View Co.

GREAT NORTHERN DEPOT. The first railway depot in Great Falls was a boxcar. Union Depot was built in 1890, a landmark at the head of Circle Park and Central Avenue. This station burned November 4, 1915, but by 1910 had been replaced by the new Great Northern Depot shown in this image. The 1910 depot, with the old Great Northern Railroad clock tower, is now the home of Energy West. (Great Falls Photo View Company.)

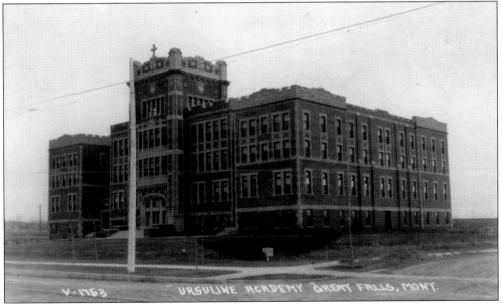

V-1763 "URSULINE ACADEMY GREAT FALLS, MONT.

URSULINE. On a rising hill at the 2300 block of Central Avenue, the Ursuline Convent of the Holy Family built the Mount Angela Ursuline Academy to replace earlier facilities at St. Peter's Mission. Architect George H. Shanley designed the convent and school in modern Gothic Revival style. Opened in 1912 as a school for girls, this was expanded to include boys in 1927. The Ursulines worked with the Sisters of Providence to open the College of Great Falls in 1932.

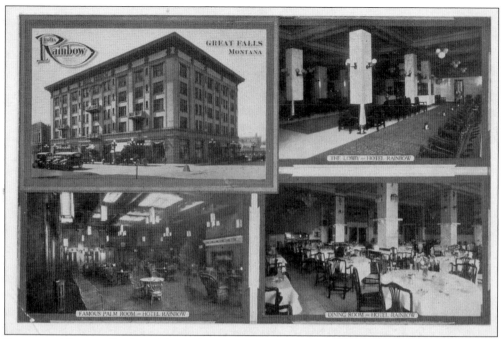

RAINBOW HOTEL. Designed by architect George H. Shanley and built for the Great Falls Townsite Company, the Rainbow Hotel opened in May 1911. Managed by William E. Ward, the hotel featured an exceptionally large reception room, the Palm Room, women waiters in its fine dining room, and a grand lobby. Within three years the Rainbow Hotel needed expansion. Today it serves as a fine retirement home.

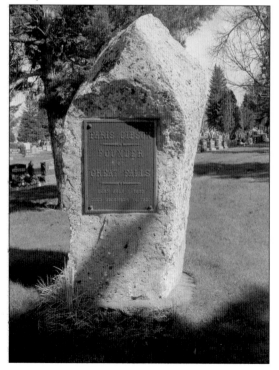

PARIS GIBSON GRAVESTONE. Near the entrance to Highland Cemetery, a 7-ton rock greets visitors. Paris Gibson died December 16, 1920, at age 90, and this grave marker was dedicated in 1952 to honor him for his strength and durability. This syenite porphyry stone, from the "Beartooth" formation in Liberty County, is harder and more durable than flint. It has withstood the extremes of climate for thousands of years and is a fitting monument to the founder of Great Falls. (Ken Robison.)

Four

HARD TIMES

BUT MOVING FORWARD

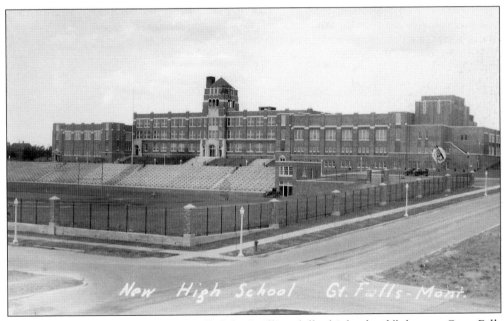

MILLION DOLLAR HIGH SCHOOL. Called the "million dollar high school," the new Great Falls High School was designed by architects George W. Bird, Johannes H. Van Teylingen, and Ernest B. Croft. Located between Eighteenth and Twentieth Streets and Second and Fourth Avenues South, former students wanted the new high school named for Charles M. Russell, while businessmen wanted it to be James J. Hill High School. Great Falls High School opened in the fall of 1931.

WILL ROGERS ARRIVES. In tribute to his warm friendship with Charles M. Russell, famed humorist Will Rogers visited Great Falls in March 1927, a year after the artist's death. Pictured, from left to right, are Mint owner Sid Willis, artist Charles Beil, aviator Will Rogers, and businessman Henry P. Brown. Rogers visited haunts of his old friend, including Russell's Studio and a Russell Memorial Exhibit art show. That evening, Rogers, America's greatest humorist, performed to a delighted capacity crowd at the Grand Opera House. (Great Falls Photo View Company.)

WILL ROGERS PARADE. Riding in an old stagecoach brought to Great Falls and driven by A. C. Tingley of Big Sandy, Will Rogers was escorted by old-time cowboys and Native Americans in a parade up First Avenue North. At the end of his visit, Rogers pledged $500 of the "loot" from the previous night's performance to help establish a Charles M. Russell Memorial building. Rogers called his friend "the great painter, who will live in history as America's most famous cowboy." (Great Falls Photo View Company.)

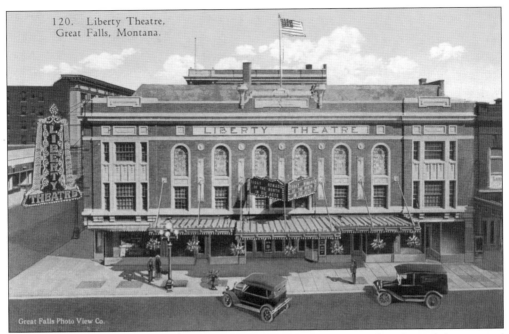

LIBERTY THEATER. On August 23, 1921, the Liberty Theater opened at Central Avenue and Third Street to acclaim by the *Great Falls Tribune* as "a jewel box." More than 3,600 attended the two opening night showings of "Nomads of the North." The first "talkie" was shown on August 29, 1928, Al Jolson's "The Jazz Singer." (Great Falls Photo View Company.)

KAUFMAN'S Downtown Great Falls featured a vibrant shopping area through the years. Today only one original store continues to operate, and Kaufman's is one of only a handful of early Montana clothiers still in business. Mose Kaufman opened Kaufman's at 218 Central Avenue in 1894. Since 1925, the family-owned store has operated at 304 Central Avenue. This image shows Kaufman's after major remodeling in 1938. (John J. Yaw; Ike Kaufman.)

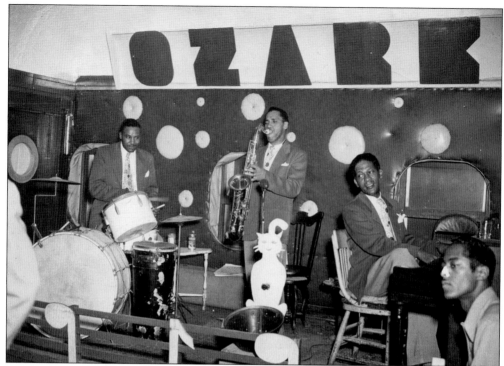

OZARK BOYS. In 1938, young Bob Mabane with his golden tenor saxophone played with Charlie "Byrd" Parker in the Jay McShann Band in Kansas City. A decade later, Mabane arrived in Great Falls to join Leo LaMar at the Ozark Club. The Ozark Boys in 1950 featured, from left to right, Dick Brown on drums, Bob Mabane on tenor sax, and Chuck Reed on jazz piano. (Sugar LaMar.)

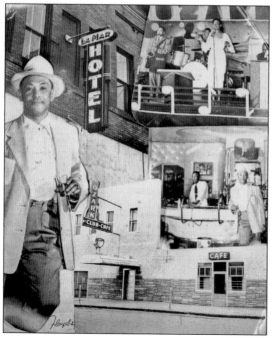

OZARK CLUB MOSAIC. This mosaic tells the amazing story of the Ozark Club. Dashing Leo LaMar, left, ran the whole operation while his wife, Beatrice, organized prostitution on the second floor of the LaMar Hotel. Vivian Dandridge and other singers, exotic dancers, and jazz players performed with the Ozark Boys. Leo kept a watchful eye from the bar while gambling occurred in the back. (Sugar LaMar.)

BLACKSTONE APARTMENTS. Great Falls was an apartment town from its early days. The showcase Blackstone Apartments, designed by architects Henry Hall Johnson and George H. Shanley, were built in 1917 at 344 Third Street North. Its eclectic style was popular during the 1910s. Among the many prominent residents of the Blackstone over the years was accomplished artist Fra Dana, who lived and painted in the Blackstone for 11 years until her death in 1948. (THM.)

FRA DANA PAINTER. Young Fra Dinwiddie came to Wyoming by stagecoach in 1891 and married rancher Edwin L. Dana. Together they ranched in Wyoming, then near the town of Cascade for many years before moving to Great Falls. Always fond of painting, Fra Dana finally had time to pursue her love of art. This oil painting from about 1935 shows Rebecca Sue Ford Bovey, granddaughter of Sun River pioneer Robert S. Ford.

OLD TOWN. Upon the death of Joseph Sullivan of Fort Benton in 1940, his daughters gave his historic saddlery to Charles Bovey. In the summer of 1941, Bovey opened a composite frontier town called "Old Town," in Mercantile Hall at the North Montana Fair in Great Falls. Old Town became a popular event at the fair for two decades.

CHARLES AND SUE BOVEY. Starting with Old Town in Great Falls, Charlie and Sue Ford Bovey looked for larger worlds to conquer. From 1947, the Bovey's began turning the near ghost town of Virginia City into a tourist mecca. Along the way, they recreated the neighboring town of Nevada City with Old Town buildings. (THM.)

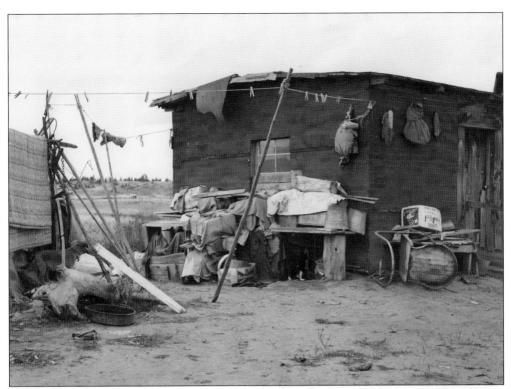

HILL 57. A bluff on the high bench northwest of Great Falls, Hill 57 was named for railroad magnate James J. Hill and for early Heinz 57 brand advertising numerals "57" painted by Art Henck on the slope. By the 1930s, the Little Shell Native American tribe lived on Hill 57 for many years in poverty and marginal housing conditions. Sister Providencia Tolan, a nun at College of Great Falls, worked tirelessly to relieve the plight of these Native Americans.

JUDGE CHARLES N. PRAY. Montana congressman Charles N. Pray, the "father of Glacier National Park," skillfully gained approval of the bill creating the park in April 1910 despite opposition from the powerful Speaker of the House, Joe Cannon. Pray later moved to Great Falls, where he served as first U.S. District Court judge in Cascade County from 1924 until his death in 1963. (OHRC.)

MITCHELL PARK'S KKK. By the late 1930s, Tourist Park was replaced by Mitchell Park, named for former mayor Harry B. Mitchell. Works Progress Administration (WPA) projects installed a public swimming pool and a stone wall to separate the park from the railroad tracks. WPA workers designed the letters "KKK" into the stone wall, causing consternation when it was discovered and embarrassed excuses as it was quickly rebuilt. The Ku Klux Klan had limited support in Great Falls in the 1920s but had faded by the time of this pathetic joke.

MONTANA SCHOOL FOR THE DEAF AND BLIND. The Montana School for the Deaf and Blind moved to Great Falls from Boulder, Montana, in 1937. This new school opened on Second Avenue North and Thirty-Eighth Street. Through the efforts of Great Falls mayor Ed Shields, the school received funds from all over the country through the "Shep Fund," named for the famed faithful dog at Fort Benton.

THE MAN FROM MONTANA. Mike Mansfield, a man of few words and great achievements, was born in New York City on March 16, 1903. He was raised in Great Falls until he joined the navy at age 14. Returning to Montana for college and teaching, Mansfield was elected to Congress, first to the U.S. House of Representatives and in 1952 to the Senate. (Tom Mulvaney.)

FIRE DESTROYS OZARK CLUB. Leo LaMar died from a heart attack on June 20, 1962. Three weeks later, just after midnight on July 12, firemen arrived on the scene and herded about 50 employees and patrons down the stairs and to safety as a fire swept through the Ozark Club and Geiger's Repair Shop next door. Hot, tar-fed flames destroyed the famed club, bringing an end to the Great Falls jazz capital era. Rumors persist that the fire was arson. (Ray Ozmon; THM.)

PRESIDENTIAL VISIT. On September 26, 1963, just two months before his assassination, Pres. John F. Kennedy visited Great Falls. Landing at Malmstrom Air Force Base, the president toured a Minuteman missile silo similar to the "ace in the hole" he had had in his arsenal during the Cuban Missile Crisis.

CHARLES M. RUSSELL HIGH SCHOOL. The population of Great Falls doubled between 1930 and 1960, overwhelming the capacity of Great Falls High School. Named for the cowboy artist, Charles M. Russell High School opened in the fall of 1965. Located on the northwest side of the city, the CMR Rustlers quickly established a reputation statewide with frequent championship football teams led by coach Jack Johnson.

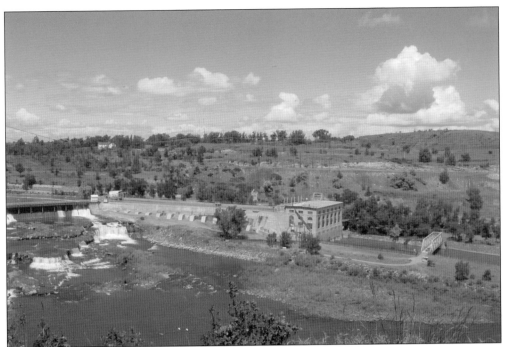

ALL FALL DOWN. Great Falls suffered staggering blows economically by 1980, including loss of railroad repair yards and the Anaconda Company. Crowned by demolition of the city's landmark symbol, the Big Stack, in 1982, all buildings but one were removed from Anaconda Hill. The hill has reverted back to Indian Point, with just the endangered Boston and Montana white barn on the left side of this image occupying the former bustling industrial hill. (Ken Robison.)

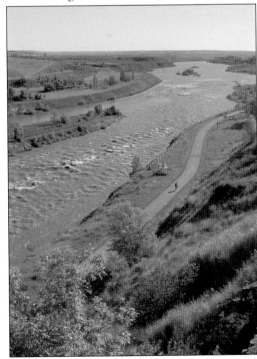

RIVER'S EDGE TRAIL. Extending more than 45 miles along both sides of the river, the paved recreational River's Edge Trail is the perfect showcase for the Missouri River. The trail is popular for jogging, walking, biking, or skating and is shown in this view of the trail just below Black Eagle Falls on the way down river toward Rainbow Falls. (Ken Robison.)

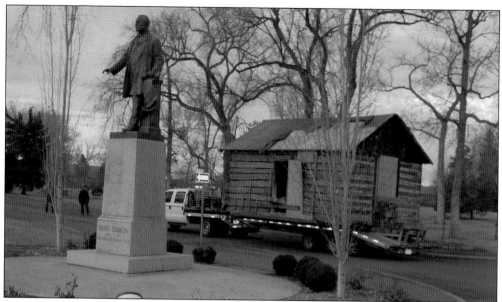

FIRST HOME ON THE MOVE. To save the Vinegar Jones cabin from demolition, with Scotty Zion's help the Historic Preservation Advisory Commission organized a move of the cabin in 2004. The Tamietti Company of Butte loaded the tiny cabin onto a trailer. This remarkable scene shows the move of Great Falls' first home through the streets, past the statue of Paris Gibson, and to its new home in the city's premier Gibson Park. (Ken Robison.)

3-D CLUB. Black Eagle began as Little Chicago, home of many European immigrants working for the Anaconda Company. Tommy Grasseschi, one of those immigrants, and his wife, Dorothy, had an idea for a supper club and a slogan: "Drink, Dine and Dance." This became the 3-D Club, starting in an old two-story brick building on the corner of Nineteenth Street and Smelter Avenue. (Mark Grasseschi.)

Five

FROM MARK TWAIN TO YO-YO MA
CULTURE, ARTS, AND SPORTS

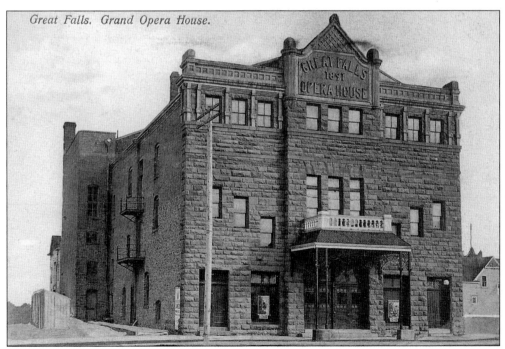

GRAND OPERA HOUSE. Designed by architect Oscar Cobb of Chicago, Illinois, this crown jewel, the Grand Opera House, was built in 1891 of brick and rough-cut stone from local quarries. At a cost of $50,000, the building's Romanesque décor provided residents with an exceptional cultural center. Sadly, a wrecking ball demolished the Grand Opera House in 1955. (Tom Mulvaney.)

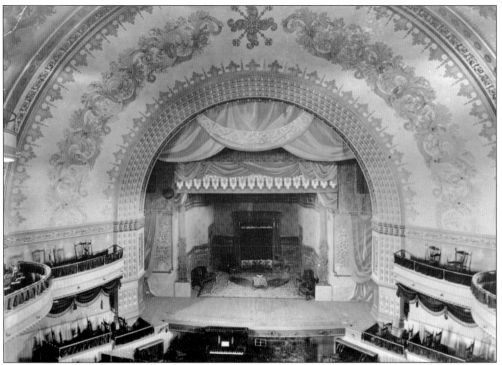

INTERIOR OF THE OPERA. The Grand Opera House opened January 4, 1892, with McKee Rankin's "The Cannuck" for an audience of 1,200. This 1899 photograph shows the proscenium arch featuring scrollwork in stucco and private balconies with solid brass railings. Some 600 electric lights studded the arches, walls, and ceiling to illuminate the interior. (THM.)

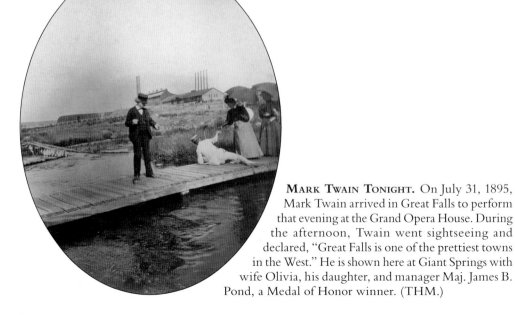

MARK TWAIN TONIGHT. On July 31, 1895, Mark Twain arrived in Great Falls to perform that evening at the Grand Opera House. During the afternoon, Twain went sightseeing and declared, "Great Falls is one of the prettiest towns in the West." He is shown here at Giant Springs with wife Olivia, his daughter, and manager Maj. James B. Pond, a Medal of Honor winner. (THM.)

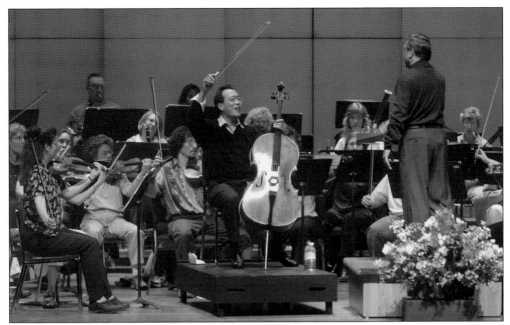

YO-YO MA. On May 14, 2004, Yo-Yo Ma rehearsed with the Great Falls Symphony under director Gordon J. Johnson before a performance that evening at the Mansfield Center for the Performing Arts in the Civic Center. (Stuart S. White; *Great Falls Tribune*.)

PUBLIC LIBRARIES. Great Falls' first library opened in January 1891 at Third Street North and Second Avenue. The Valeria Library, a one-story brick building, was named for Paris Gibson's wife, an invalid who lived in Minneapolis. A second library, the Carnegie or Great Falls Public Library, opened in 1903. In this image, Valeria Library is on the left and Carnegie Public Library is on the right. (Andrew Finch.)

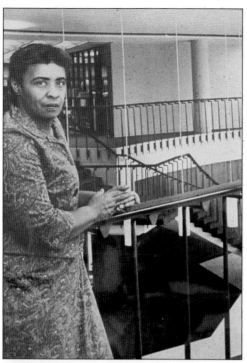

THE EXCEPTIONAL ALMA JACOBS. In 1954, Alma Smith Jacobs was appointed director of the Great Falls Public Library, the first African American library director in Montana. Jacobs was an exceptional librarian, quietly effective and highly respected, and she led the Great Falls community to resolve many civil rights issues during the 1950s and 1960s. (Great Falls Public Library.)

THE HOUSE THAT ALMA BUILT. Alma Smith Jacobs worked tirelessly to gain funding for a new, state-of-the-art library. On her third try, an election bond issue narrowly passed, and the new Great Falls Public Library opened on November 12, 1967, on the site of the Carnegie Public Library. In 2009, the city commission declared Alma Smith Jacobs Week and a new plaza, highlighted by a sandstone arch with spraying water, was dedicated the "Alma Jacobs Memorial Plaza An Exceptional Librarian and Community Leader." (Ken Robison.)

MONTANA'S CONSCIENCE. Joseph Kinsey Howard, journalist and historian, earned the sobriquet of "Montana's Conscience." Born in 1906 in Iowa, Howard graduated from Great Falls High School in 1923 and at age 20 became the news editor at the *Great Falls Leader*. In 1943, his landmark book, *Montana, High, Wide and Handsome,* was published. (THM.)

Charley Pride
In Concert Saturday, May 9th 7:30pm
Tickets: 406-455-8514 Great Falls Civic Center Theater

HOMETOWN CHARLIE PRIDE. Charlie Pride, seen here in 2005 at the Civic Center, came to Montana to play baseball but left the state as the nation's first African American country music star. Pride lived in Helena in the mid-1960s and in Great Falls during 1967–1968. He got his start performing at The Ranch with Dave Wilson and Jim Lynn. Pride has returned many times over the years, renewing old friendships and playing to packed houses.

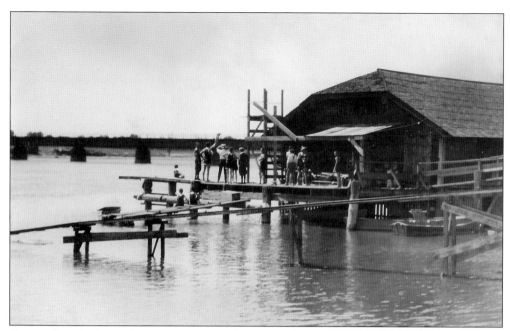

EARLY GREAT FALLS SWIMMING. Located on the Missouri River, Great Falls had an early, natural outlet for swimming despite the dangers. In the early years, the Great Falls Boat House located on Broadwater Bay served as the local swimming hole for youngsters. Many newspapers sadly relayed the story of young swimmers swept by the current or caught in the undertow and drowned in the Missouri River. (Andrew Finch.)

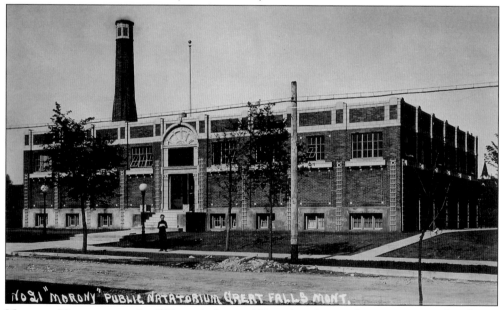

MORONY NATATORIUM. In 1916, an indoor public swimming pool was constructed and over time young swimmers moved in to the safety of the Morony Natatorium from the dangers of swimming in the Missouri River. The natatorium, located in Morony Park at 111 Twelfth Street North, was named in honor of John G. Morony, Montana Power Company developer. (Tom Mulvaney.)

EARLY FOOTBALL. The first school football games played in Great Falls featured the Fort Shaw Indian School team in the late 1890s. In 1900, Great Falls High School fielded its first football team. The team improved each year, leading to its championship win in Montana in 1906. This photograph shows the Great Falls team on the field about 1906. (Ike Kaufman.)

EARLY BASEBALL. Joseph Tinker began his career in 1900 with the Great Falls Indians at the age of 19. A good hitter, Tinker was a spectacular fielder with exceptional speed, and this talent propelled him by 1902 to the Chicago Cubs, where the famed double-play combination from "Tinker to Evers to Chance" led all three players to the MLB Hall of Fame. Toward the end of his career, "Iron Man" Joseph J. McGinnity, another Hall of Famer, played for Great Falls in 1917.

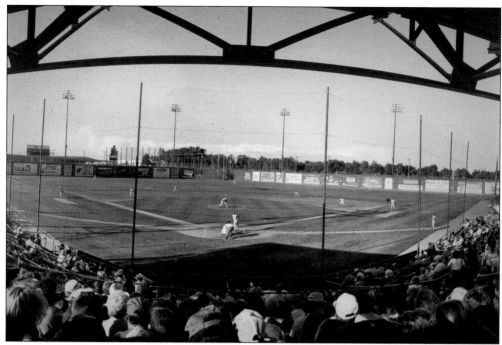

GREAT FALLS BASEBALL PARK. Since 1948, Great Falls has been home to professional baseball, with its team playing in the Pioneer League. Rookie teams for major league clubs like the Los Angeles Dodgers, San Francisco Giants, and Chicago White Sox have brought All-Stars like Bobby Cox, John Roseboro, Pedro Martinez, and Jonathan Broxton to Great Falls. In this scene from about 1992, the Great Falls Dodgers are on the field. (Ray Ozmon; Logan Hurlbert Great Falls Baseball Hall of Fame.)

FAN FAVORITE EDDIE REED. Among the many great baseball players to play with Great Falls, none was more popular with the fans than Eddie Reed. A former Negro League player in the days of segregated baseball, Reed combined great hitting and fielding with a winning smile, making him a crowd favorite. (Logan Hurlbert, Great Falls Baseball Hall of Fame.)

WORLD WAR II HOCKEY. Ice hockey has a long tradition in Great Falls, beginning with frozen lakes and winter ice on Gibson Lake. This 1944 photograph shows the U.S. Army Air Corps Ferrying Command 7th Ferrying Group hockey team, the Gore Field Fliers, ready to play the Great Falls Hornets. (Ike Kaufman.)

NATIONAL CHAMPS GREAT FALLS AMERICANS. With the end of World War II, several young Canadians, including Bill Ukranitz, came to Great Falls to play hockey and form the nucleus of the Veterans of Foreign Wars team. By 1950, the team was renamed the Great Falls Americans and in 1954—in a Cinderella story performance—the Americans won the U.S. National Senior Amateur Hockey Championship in Clinton, New York. (William R. "Bill" Ukrainetz.)

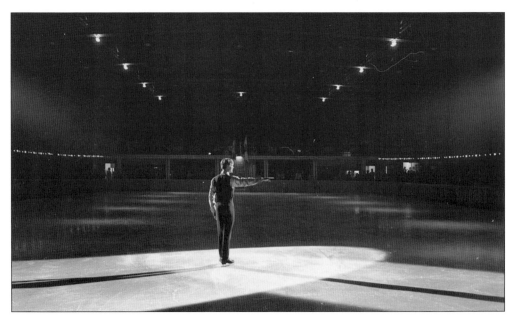

Figure Skating Champions. Great Falls has been home for two U.S. National Men's Singles Figure Skating Champions, Scott Davis (1993 and 1994) and John Misha Petkevich (1971). In this image, young Petkevich performed at the Civic Center for the Great Falls Figure Skating Club before competing in two Olympics. Petkevich attended Oxford University as a Rhodes Scholar. (Ray Ozmon; THM.)

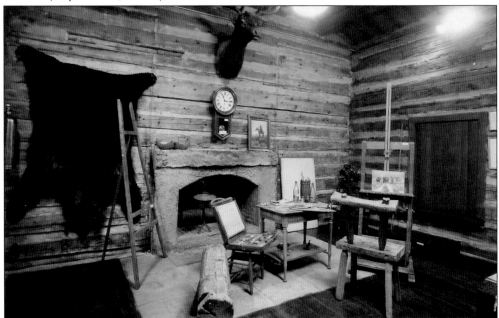

Charles M. Russell's Cabin. Soon after Charles M. and Nancy Russell moved to Great Falls in 1897, with the help of Charles's father, they purchased lots on Fourth Avenue North and built a home. In 1903, he built a log cabin studio next to their home where, in addition to at his summer home in Glacier Park, Charles created the masterpieces that brought him international fame. (Andrew Finch.)

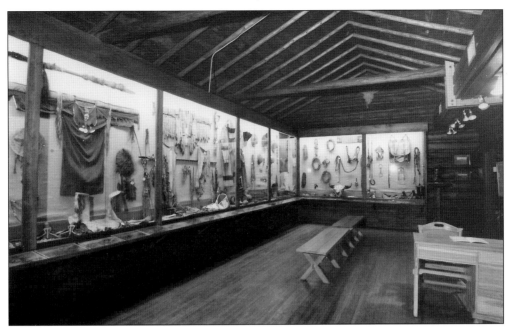

RUSSELL STUDIO DISPLAY. Following Charles Russell's death in October 1926, Nancy Russell deeded the log cabin studio and family home to the city of Great Falls. Also given were Charles's equipment and collection of Native American and cowboy memorabilia and models. The studio opened with interesting displays. In 1951, after the death of longtime friend Josephine Trigg, funds were raised to build the first Charles M. Russell Museum.

THE COWBOY AND THE BOXER. Great Falls cowboy artist Charles M. Russell, an avid boxing fan, greeted world heavyweight champion Jack Dempsey at Great Falls Park in 1923. Dempsey trained at this park from May 23 to July 3 before fighting Gene Tunney at oil boomtown Shelby on July 4, 1923. Today this historic site is Verde Park, south of Prospect Heights.

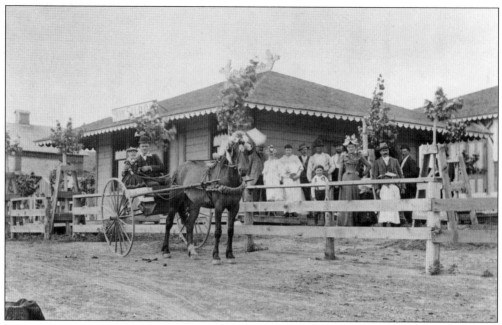

Dempsey Inn. Leased from the Volk family in 1914, this building operated as Park Saloon roadhouse in Great Falls Park on Upper River Road until Prohibition. Jack Dempsey leased the complex from Christopher Volk and used the home as his training headquarters in 1923. The boxer's name remained when the roadhouse reopened as the Dempsey Inn. After Prohibition, the Dempsey Inn was a popular nightspot until it was partially destroyed by a fire in 1966 and was later demolished. (THM.)

Champion Joe Louis. In April 1945, world heavyweight champion Sgt. Joe Louis visited the troops at Great Falls Army Air Base en route to a tour of Alaska. The great boxer refereed an amateur boxing match, visited the Ozark Club, and attended Union Bethel A.M.E. Church. In this image, Louis joins Leo and Bea LaMar in the gambling room in the back of the Ozark Club. (Sugar LaMar.)

NORTHERN MONTANA FAIR. Cascade County fairs first were held at Black Eagle Park, then were moved to the northwest side. In the late 1920s, planning began for a new Northern Montana State Fairgrounds at Third Street Northwest. Opening day in 1931 drew a massive crowd of 130,000. New buildings, several in an art deco style, appeared throughout the 1930s, some of which were financed by the Works Progress Administration.

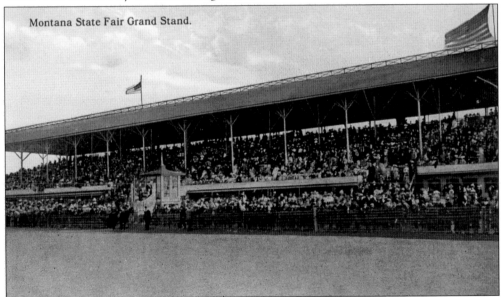

Montana State Fair Grand Stand.

TRAGIC ACCIDENT. On August 9, 1946, a crowd of 20,000 in the fair grandstands was stunned when three U.S. Army Air Corps A-26 Invader bombers flying overhead in formation collided. Debris fell to the ground, missing the grandstand, but one A-26 crashed at the north end of the racetrack striking a horse barn that resulted in the death of two civilians and 19 horses. A second A-26 crashed 5 miles north of the fairgrounds, and the third aircraft limped back to East Base. Four aviators were killed.

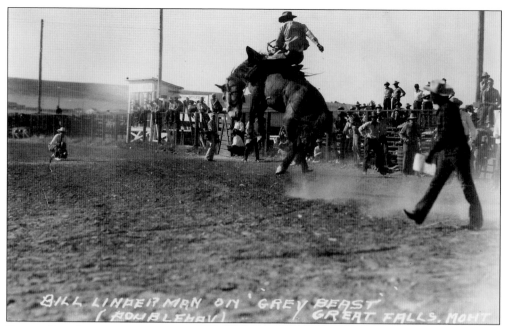

RODEO BILL LINDERMAN. World champion bucking bronco rider Bill Linderman of Montana rode Grey Beast at the rodeo in Great Falls. During the 1940s and 1950s, Linderman reigned supreme on the Rodeo Cowboys Association circuit. A heroic-size sculpture of Bill Linderman, created by Montana sculptor Bob Scriver, stands in the National Cowboy Hall of Fame. (Tom Mulvaney.)

FIRESIDE BOOKS. On October 1, 2005, the lights went out at 614 Central Avenue. On that day, Fireside Books closed its doors and Montana lost an exceptional antiquarian bookstore. Opened in 1994, the store and owner Niel Hebertson quickly established a reputation around Montana as a friendly place to find rare books for the discerning collector or common books for a good read. (Ken Robison.)

98

Six

FLYING OFF TO WAR
THE MILITARY IN PEACE AND WAR

SOLDIERS' MONUMENT. Erected in 1898, the Soldiers' Monument in Highland Cemetery was among the first in the United States to pay tribute to both the Confederacy and Union. It also honors American Indian Wars and Spanish-American War soldiers. The cannon's history is inscribed in the stone: "Built 1854; sent South 1860; recaptured by North 1862; in service until 1865; on Bedloe's Island, New York 1868 until erection of Statue of Liberty; presented 1898 to Sheridan Post Grand Army of the Republic, Great Falls, Montana." (Ken Robison.)

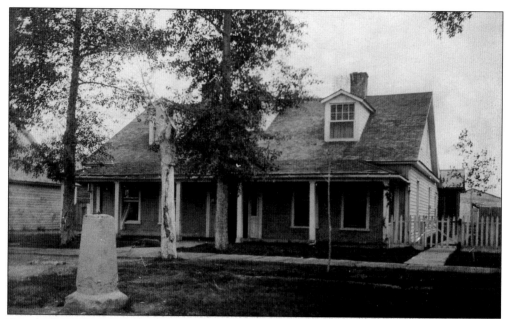

INDIAN WARS. By the mid-1860s an increasing flood of white settlers to the Montana Territory triggered incidents with Blackfoot Indians. In response, in 1867 Fort Shaw (named for Civil War hero Col. Robert G. Shaw) was built in central Sun River Valley. This photograph, from about 1900, shows the quarters for then Col. John Gibbon, commanding the 7th Infantry in action during the Sioux War in 1876 and the flight of the Nez Perces in 1877. (THM.)

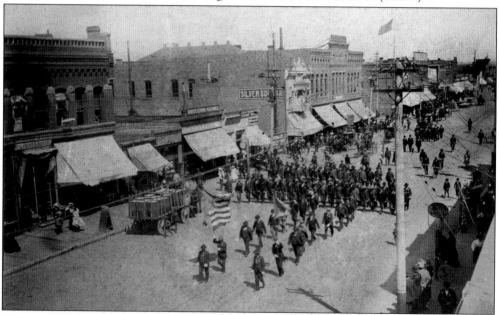

SPANISH-AMERICAN WAR. Patriotic parades bid farewell to soldiers and greeted them upon return from the Spanish-American War and World War I. Separate parades were held for white and African American soldiers. In this image, policemen, dignitaries, and soldiers in field dress march down Central Avenue to say goodbye to Company A of the Montana National Guard at the Great Northern Depot. (THM.)

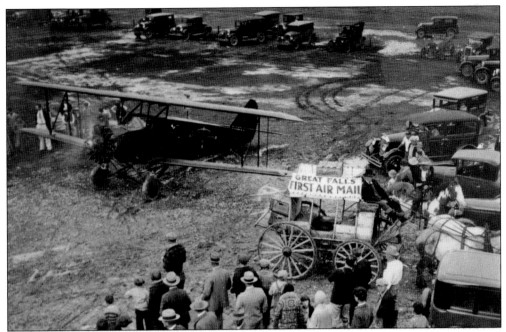

VANCE FIELD. In 1927, pioneer local pilot Earl Vance built an airfield across the Missouri River north of Great Falls. The next year, a National Air Tour of 100 airplanes arrived at Vance Field. On July 28, 1928, a Fokker Super Universal aircraft landed mail and six passengers with a ceremonial stagecoach waiting to take the mail to the downtown post office. (THM.)

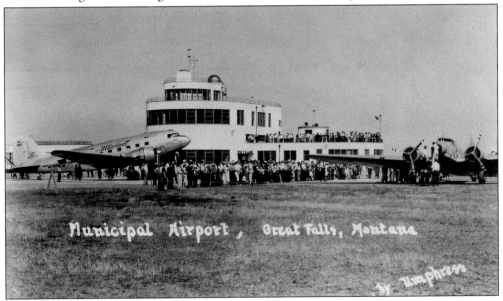

GORE FIELD. During 1931, the Great Falls city government dedicated a municipal airport at Gore Hill, named for farmer Samuel Gore. Early in World War II, Gore Field became the last stop in the United States for lend-lease aircraft bound for Great Britain, and later the Soviet Union. Civil and military operations continue today at Great Falls International Airport, the home of the 120th Tactical Fighter Wing of the Montana Air National Guard. (J. E. Umphrees; Tom Mulvaney.)

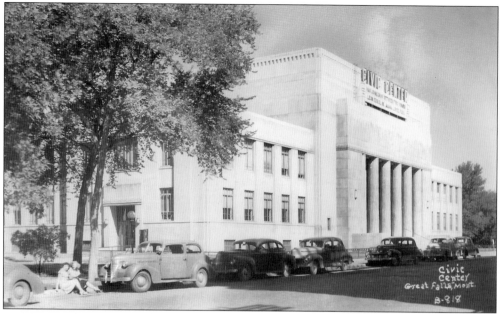

THE 7TH FERRYING COMMAND. In January 1942, the 7th Ferrying Group moved from Seattle to Great Falls with temporary headquarters at the new Civic Center while facilities were prepared at Gore Field. The Works Progress Administration built the Civic Center in 1939–1940. The 7th Ferrying Group set up stations from Great Falls to Alaska to support the transfer of aircraft from the United States to the Soviet Union.

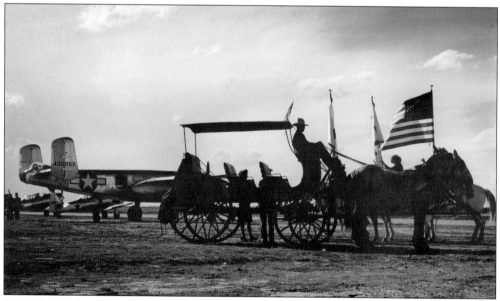

LEND LEASE AIRCRAFT. On July 4, 1944, a wagon and carriage flying an American flag are next to B-25 and T-6 aircraft with American markings. Those markings will soon be changed to Soviet Union insignias as the aircraft prepare to depart for Alaska en route to the Soviet Union. In 1944, Col. Anatol N. Kotikov, the Soviet leader at Great Falls, supervised departure of 3,204 P-39s, C-47s, B-25s, A-20s, and T-6s to the Soviet Union. By September 1945, more than 7,000 aircraft had been flown to the Soviet Union. (THM.)

AIR NATIONAL GUARD. The Montana Air National Guard has a long tradition, since the formation of the 120th Fighter Wing in 1947, of flying F-51s from their base at Great Falls. The latest model fighters have changed over the years but operations at Gore Field continue. For two decades from 1987 to 2007, the Wing flew the multi-role fighter F-16s, pictured here. (Ken Robison.)

GREAT FALLS ARMY AIR BASE. Commonly called East Base, Great Falls Air Base was constructed during 1942 in the wheat fields 6 miles east of Great Falls. Base operations during World War II included bomber training, port of embarkation to Alaskan bases, and serving as a take-off point for lend-lease aircraft for Soviet Russia. This Christmas greeting was sent from Great Falls Air Base in 1944.

103

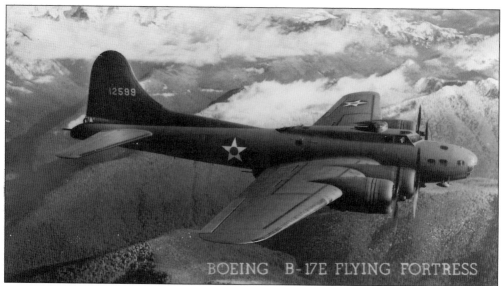

BOEING B-17E FLYING FORTRESS

BOMBER TRAINING. On July 6, 1942, the Second Air Force took command of the new Great Falls Air Base (GFAB) to perform B-17 combat crew training. Flying from British bases, the 385th, 390th, and other bombardment groups trained at East Base for performing daylight precision strategic bombing missions against German industrial and military targets. In this image, a Boeing B-17E Flying Fortress four-engine heavy bomber is on a flight-training mission out of GFAB.

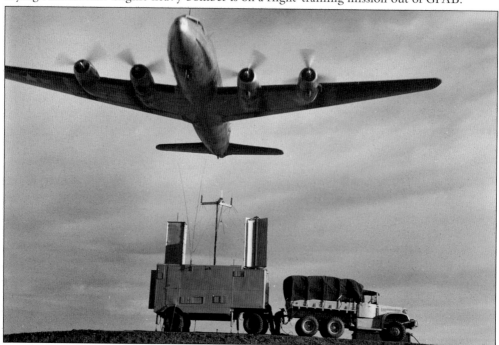

OPERATION VITTLES. In 1948, the Soviet Union closed all land travel from West Germany to Berlin, and the Berlin Blockade began. The United States and Britain began Operation Vittles, an immense airlift of supplies to some two million Berliners. Great Falls Air Force Base (GFAFB) was selected to train pilots and aircrews bound for the Berlin Airlift. This image shows a Douglas C-54 Skymaster coming low over a Ground-Controlled Approach radar van at GFAFB.

BERLIN AIRLIFT TRAINER. Great Falls Air Force Base was selected as a training base for Operation Vittles because of its good flying weather and available runways. This trainer allowed student pilots to use a flight simulator as part of navigation training. The relief map of the Berlin corridor is tracked as the radar antenna moves slowly over it. Student pilots, from left to right, are first lieutenants Robert Pfegl, Frank Simms, Lowell Wheaton, Leonard Rush, Earl Miller, and Joseph Schreiner.

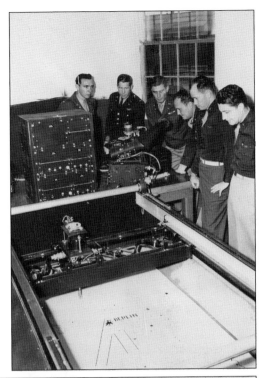

MALMSTROM AIR BASE. By 1954, the Strategic Air Command took charge of the Great Falls Air Force Base flying F-84 fighters. On June 15, 1956, the base was dedicated as Malmstrom Air Force Base, for vice wing commander Col. Einar A. Malmstrom, who was killed in an aircraft accident. Malmstrom AFB entered the space and missile age in the 1960s with the 341st Strategic Missile Wing that commanded Minuteman missile sites spread over 25,000 square miles of Montana countryside.

THE ACE IN THE HOLE. Located 25 miles east of Great Falls in Armington Coulee, this Minuteman missile site symbolizes the role of intercontinental missiles during the Cold War. In October 1962, during the Cuban Missile Crisis, Alpha 1 missile site became operational, giving Pres. John F. Kennedy his "ace in the hole" in forcing the Soviet Union to back down and remove their missiles from Cuba. (Ken Robison.)

MONTANA VETERANS MEMORIAL. On a prominent hill overlooking Black Eagle Dam, the Montana Veterans Memorial honors, with black granite tiles, all veterans of all branches of the U.S. military in peace and in war. Led by Michael Winters of the U.S. Marines, along with Great Falls veterans groups, the memorial was dedicated Memorial Day 2006. (Ken Robison.)

Seven

ON THE PLAINS
AND VALLEYS
FARMS AND RANCHES

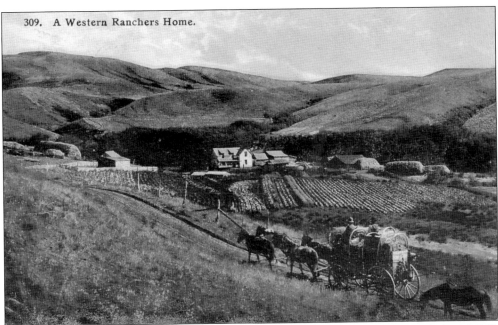

309. A Western Ranchers Home.

RANCHERS HOME. In Armington Coulee, a four-horse wagon moves east along the Great Falls to Lewistown Road. Ranching in the area began in the Sun River Valley. In 1870, Robert S. Ford trailed a cattle herd north from Colorado and turned them loose on the Sun River, opening up the Sun River range. Others followed, like Dan A. G. Floweree, Conrad Kohrs, O. B. Churchill, and E. L. Dana.

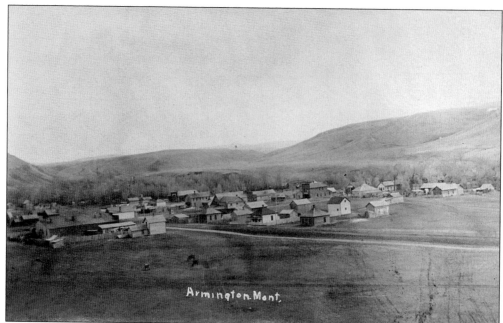

ARMINGTON. Jerould "Doc" Armington established a settlement in the late 1880s on his ranch property 3 miles southeast of Belt. The town of Armington grew as a coal mining town and departing point for bull trains loaded with supplies for Judith Basin settlers and miners in the Little Belt Mountains. With the arrival of the railroad, Armington became a rail distributing point and the end of the Neihart branch of the railroad.

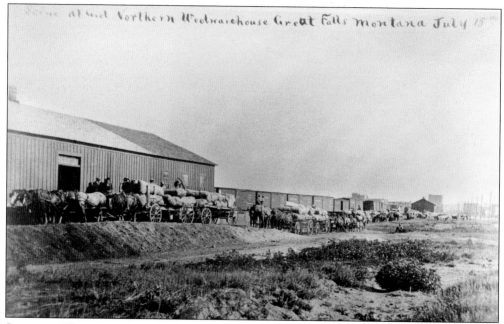

SHIPPING WOOL. While in Fort Benton, Paris Gibson set up sheep ranches along Belt and Otter Creeks, and brought purebred Merino rams up the Missouri River on steamboats. In this scene, wagons deliver wool to the Great Northern Railway's wool warehouse in Great Falls for shipment to mills in the East. (THM.)

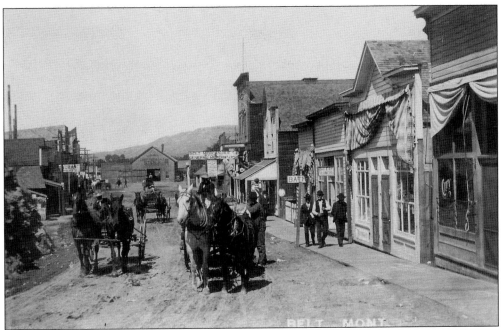

BELT. The town of Belt was originally called Pittsburg or Castner, in honor of the first resident, John K. Castner, from Pennsylvania, who opened the first coal mine in Montana in 1877. Freighting coal to Fort Benton, Castner met and married Mattie Bell Bost, an African American. Together they ran a popular hotel while founding the town of Belt.

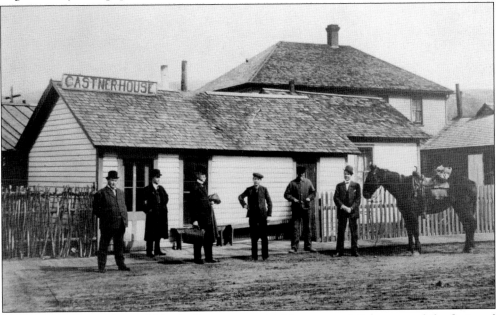

CASTNER HOUSE. John and Mattie Castner were highly respected. John opened the first coal mine and first store in Belt and was active in business, real estate, and politics. Mattie operated a popular hotel and restaurant as well as a ranch in the Highwood Mountains. The hotel resembled a Southern plantation, with so many buildings that an unidentified traveler called it "a Chinese puzzle." Travelers are pictured here waiting for a stage at the Castner House.

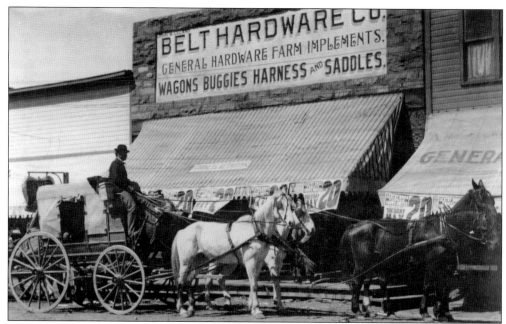

STAGECOACH AT BELT. A four-horse mudwagon stagecoach of the Great Falls to Lewistown line stops at the Belt Hardware Company to load passengers. Stagecoach service ended in 1908 when the railroads took over. Pictured at the right is Eugene R. Clingan's General Store and to the left is Belt City Hall. Clingan was Belt's first postmaster in 1885. (THM.)

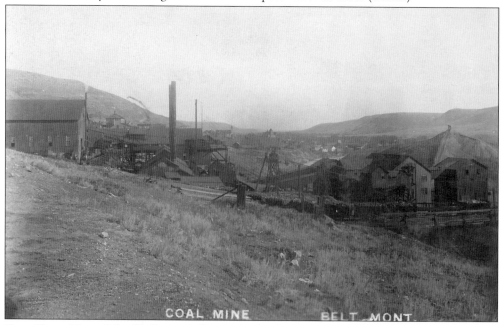

BELT COAL MINE. John K. Castner's first coal mine in Castner Coulee proved a source of good coal needed to drive the new smelters in Anaconda and Great Falls and the Great Northern trains. The Castner Coal and Coke Company was organized, and in 1895 merged under the Anaconda Copper Mining Company. Employment rose from 185 miners working in 1894 producing 800 tons of coal per day to 1,000 men mining 2,500 tons daily.

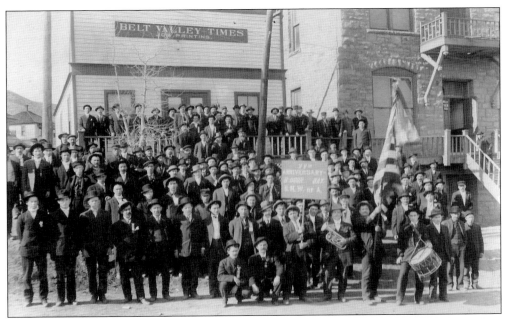

BELT MINE WORKERS. Miners from the Belt coalmines, members of the United Mine Workers of America, celebrated the 11th anniversary of the 8 Hour Day Agreement of 1907. This image shows the miners formed in front of the office of the *Belt Valley Times* on Castner Street after a parade. To the right is the two-story stone and brick Miners Union Hall built in 1897.

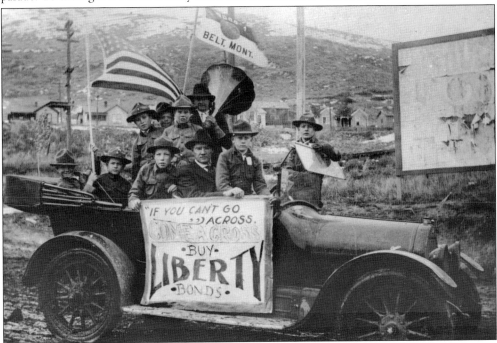

BELT BOY SCOUTS. Eight Boy Scouts and two adults ride through the mining town of Belt to encourage townspeople to buy Liberty bonds during World War I. Their sign reads, "If you can't go across, come across. Buy Liberty Bonds." The Boy Scouts began in Montana in 1910, so this was an early troop promoting patriotism during the Great War. (THM.)

BENTON LAKE NATIONAL WILDLIFE REFUGE. Benton Lake is an area of shallow lakes and marshes on the Bootlegger Trail, 15 miles north of Great Falls. In 1860, the Mullan Wagon Road Expedition camped at the northwest end called Lake Station. In 1929, Benton Lake was designated a National Wildlife Refuge, one of the first in the county, to provide habitat for migratory birds and other wildlife. (Ken Robison.)

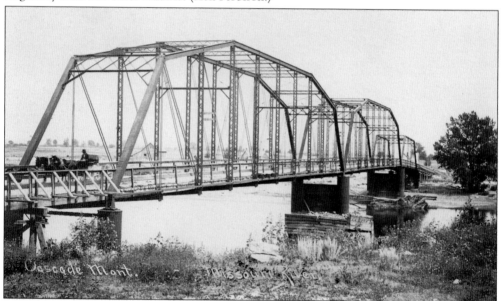

CASCADE ON THE MISSOURI. Towns by several names—such as Ulida, Gorham, and St. Clair—started near present Cascade, but on the east side of the Missouri River. The Montana Central Railway, later called the Great Northern Railroad, completed the rail line from Helena to Great Falls in 1887. A new town called Dodge developed on the west side of the river, but by November 1887 the name changed to Cascade. In 1893, this bridge was built across the Missouri River to connect Cascade and St. Clair.

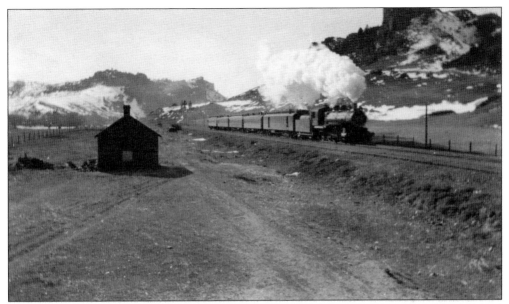

STEAM ENGINE AT HARDY. Located 8 miles south of Cascade on the west side of the Missouri River, Hardy was named for Rufus Hardy, an early settler. Hardy began in 1888 as a station on the Great Northern Railroad and as a distribution point for the Upper Chestnut Valley. In this scene, a steam engine train nears the Hardy depot on the Helena to Great Falls line. (THM.)

MISSOURI RIVER GRANDEUR. Over the years, the road from Great Falls to Helena along the Missouri River corridor has evolved from a rough trail into today's interstate highway 90. This scenic 90-mile drive passes along the canyon of the Missouri River. The highway then leaves the Missouri River to follow Little Prickly Pear Creek. (Robert Bull; THM.)

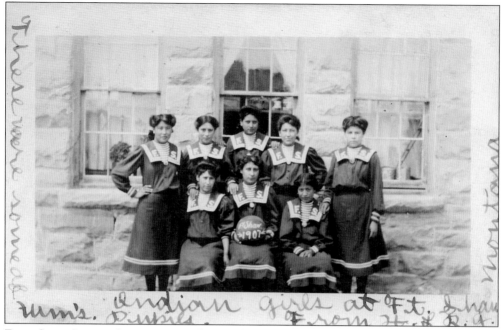

handwritten: These were some of mum's. Indian girls at Ft. Shaw Pupils. From H. & R.A. montana

FORT SHAW INDIAN SCHOOL. Fort Shaw Military Post closed in 1890, and an off-reservation Indian Industrial Training School opened at the site in 1891. Superintendent Fred C. Campbell took charge in 1898 and implemented an active sports program. The girls basketball team, led by Minnie Burton, Emma Sansaver, and Belle Johnson, became ultimate champions at the 1904 World's Fair in St. Louis.

IRON LADY MARY FIELDS. Born a slave in 1832 in Tennessee, Mary Fields came to St. Peter's Mission in early 1885 to help her friend, Mother Amadeus, an Ursuline nun. After Fields worked at St. Peter's for 10 years, Amadeus helped her open a restaurant in the nearby town of Cascade. Fields could handle a wagon and carriage, and, armed with a rifle, she became just the second female postal carrier in the United States. Until her death in 1914, Fields left many colorful stories. (Ursuline Sisters Archive.)

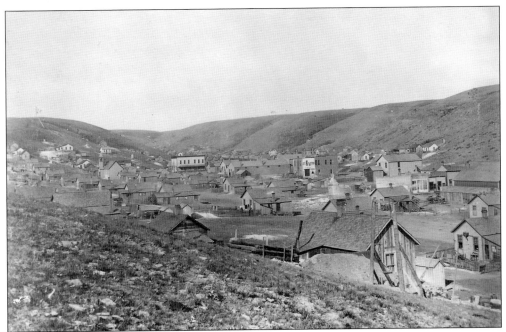

SAND COULEE TOWN. This image of Sand Coulee Town was taken from the bluff above the schoolhouse up the coulee in the 1890s. Library Hall, the rear of the company store, the bank building, livery stable, Dolson's Hall, doctor and payroll offices, and the Methodist church are all visible. The little white house near the top of the bluff is still standing.

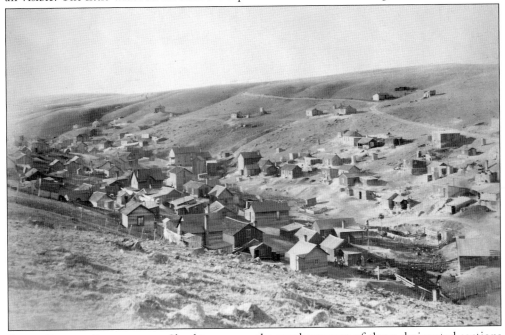

SAND COULEE SHACKTOWN. Shacktown was the southernmost of three designated sections at Sand Coulee, and contained many miners' houses, the schoolhouse, and the Finn Church. Middletown, north of Shacktown and often called "Finn Town" for its large Finnish population, contained residences and a store. Downtown, the third section, contained most businesses.

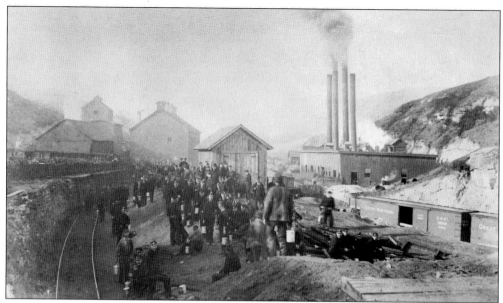

SAND COULEE COAL. Eugene Willis, an African American, located the first coal mining claim in 1884. During his first visit in 1884, James J. Hill went with Paris Gibson by carriage to Sand Coulee just as coal mines were being developed. By July 1888, a branch line of the Montana Central Railway (later the Great Northern Railroad) reached Sand Coulee and triggered a boom, bringing out coal to fuel the railway steam engines and smelters and refineries in Great Falls. Annual production during the 1890s averaged 600,000 tons per year.

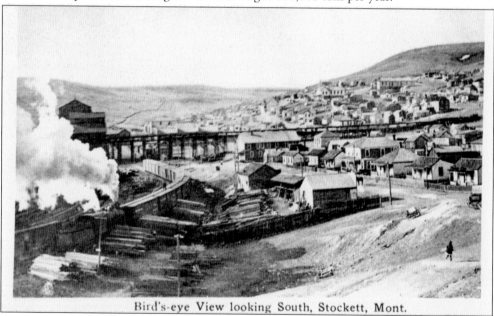

Bird's-eye View looking South, Stockett, Mont.

STOCKETT TOWN. Six miles down from Sand Coulee and 15 miles southeast of Great Falls, more coal was found to feed the railroads and smelters. By the early 1920s, the mines at Stockett were operating near capacity with more than 500 miners of Polish, Italian, Slavic, Irish, Finnish, or Scandinavian heritage. In the foreground of this 1900 image is the lumber yard of Frank Robbins, with the booming town of Stockett in the background.

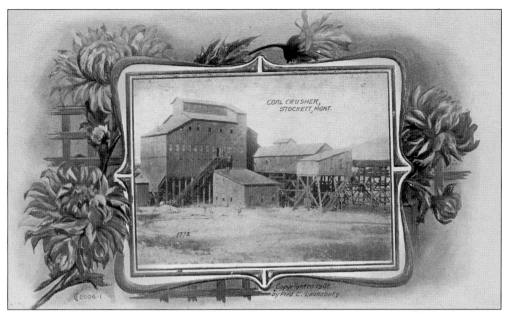

STOCKETT COAL CRUSHER. Stockett was named for Lewis Stockett, a manager of the Cottonwood Coal Company. The first mine, named No. 1, was opened around 1896. Since company managers would not allow saloons on company property, a nearby area, called the Bad Lands sprung up to satisfy the miners' thirst for beer. The coal crusher in this scene burned in 1912. (Tom Mulvaney.)

SUN RIVER LYNCHING. In late May 1888, the 25th Infantry Regiment, an African American unit, arrived for duty at Fort Shaw. On June 9, Pvt. Robert Robinson of the 25th Infantry Regiment allegedly murdered a white cowboy in Sun River. Robinson was arrested; but before he could be jailed and tried in Great Falls, a mob seized him in Sun River and hanged him in the back of George Steele's store. No one was ever brought to justice. (THM.)

SUN RIVER PICNIC. In this scene, Rev. William W. Van Orsdel, or Brother Van, standing at the back right, joins Sun River residents for a picnic on the Sun River in the 1890s. Van, a frontier circuit riding Methodist missionary from his arrival in Montana Territory in 1872, founded more than 100 churches, a university, and six hospitals and children's homes in his 47-year ministry. (Andrew Finch.)

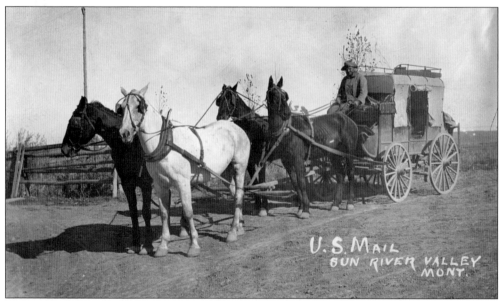

SUN RIVER STAGE. This four-horse U.S. Mail stagecoach was driven by Mr. Kriss in the Sun River Valley in 1910, the last year the stagecoach operated. Sun River station provided meals for stage passengers on the Fort Benton to Helena route. After 1910, mail and passengers traveled by railway, which by then extended into the Sun River valley. This image was taken in front of the Davies ranch. (THM.)

ADAMS STONE BARN. The remarkable James C. Adams, born in Kentucky in 1846 and a Civil War prisoner at age 16, came west in 1864 and joined the Diamond R as a wagon boss. Adams settled on the Sun River, 2 miles below the crossing, and began raising stock. In the above image, Adams is mounted on his horse, Old Socks. James C. Adams built the landmark stone barn in the image below in 1885. Adams hired Canadian William Bruce and two Swedish stonecutters to hand-cut blocks of sandstone from a nearby quarry. The stone was hauled by buckboard to the Adams ranch. The archway stones were shipped by steamboat from the Midwest. The Adams family celebrated completion by holding a roller skating party on the second floor. The 140-foot-long, two-story structure was added to the National Register of Historic Places in 1979.

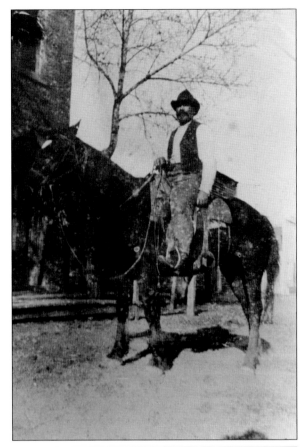

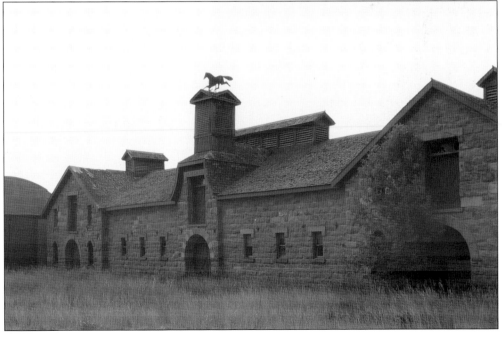

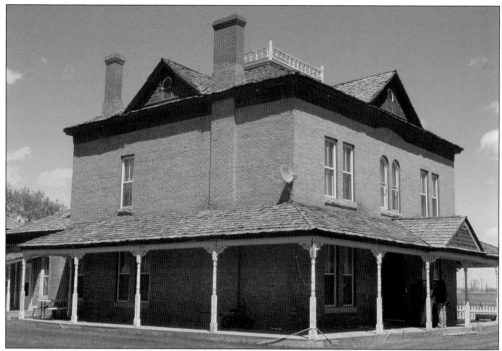

THOMAS COUCH MANSION. Capt. Thomas Couch built this historic home on the Robert Vaughn homestead on the Sun River 2 miles from the Leavings in the spring of 1889. The Couch brick mansion incorporated three walls of Vaughn's original stone house in the northwest corner. Couch, who was instrumental in bringing the Boston and Montana smelter to Great Falls, hired artist C. E. Matthews to decorate the interior of the mansion.

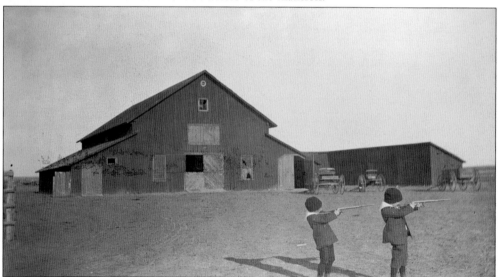

THOMAS COUCH BARN. In June 1890, Capt. Thomas Couch began building a 36-by-80-feet barn on his Sun River ranch. The barn was able to stable 50 head of horses that were used on his two racetracks. Couch's ranch of more than 2,000 acres included many thoroughbred horses and highbred cattle. In this image taken around 1900, Couch's two sons are shown playing with toy rifles. (THM.)

Eight

GOING TO THE MOUNTAINS

MINES AND RECREATION

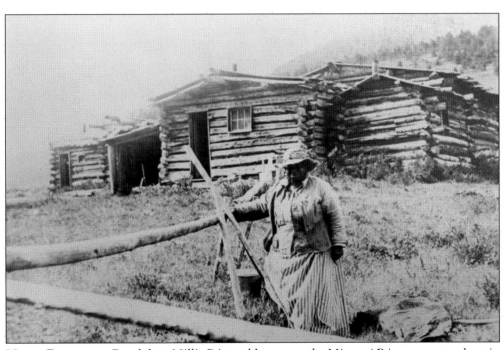

MILLIE RINGGOLD. Freed slave Millie Ringgold came up the Missouri River on a steamboat in 1878 and two years later joined the Yogo gold stampede in the Little Belt Mountains. Opening a hotel and restaurant in Yogo City, Ringgold did good business until the boom went bust in the early 1880s. Until her death in 1906, she continued to live alone and work her claims in Yogo City. (OHRC.)

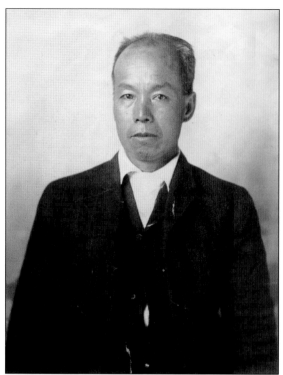

CHINESE HERITAGE. For years, Chinese people lived in Sun River, Neihart, and other towns and served as cooks on ranches. Wong Ching, shown in this photograph, was a cook for the James C. Adams ranch. From its beginning, Chinese people were not allowed to live in Great Falls. The Great Northern depot carried a sign that read, "Chinaman don't let the sun set on you here." George B. Wong arrived in 1938 and was the first person of Chinese heritage to live in Great Falls. (James C. Adams Stone Barn Collection.)

MISSOURI RIVER FLOOD. The Missouri River flows through the heart of Cascade County. Dams have reduced the threat of spring flooding, although some floods still occur. On June 8, 1908, the Missouri River flowed over its banks and out of control at Great Falls, damaging Black Eagle Dam and the walking bridge and powerhouse buildings. (THM.)

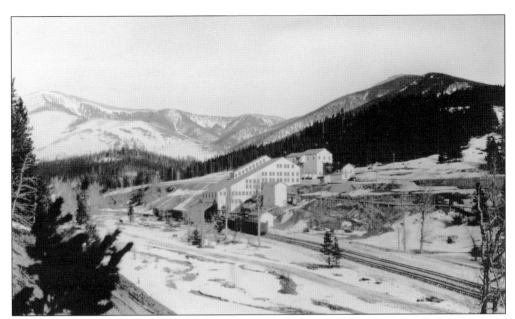

BARKER/HUGHESVILLE. Earlier known as Goldrun and Clendenin, Barker was a silver boomtown in the Little Belt Mountains, located 10 miles southeast of Monarch. Barker boomed with the opening of the silver smelter in Great Falls and the arrival of the Great Northern Railroad's Belt Mountain line. The silver market slumped during the Panic of 1893, and the boom ended. In 1927, the St. Joseph Lead Company built this mill at nearby Hughesville to smelt and refine lead and other minerals, an operation that lasted until 1931. (THM.)

SLUICE BOXES STATE PARK. In the Little Belt Mountains, 15 miles south of Belt, is Sluice Boxes State Park with its strikingly rugged 500-foot limestone walls that narrowly constrict Belt Creek into a 1.5-mile long narrow gorge. Early miners were reminded of the sluice boxes they used while mining for gold. The Montana Central Railroad built a spectacular line through the canyon to reach the Neihart silver mines. (Tom Mulvaney.)

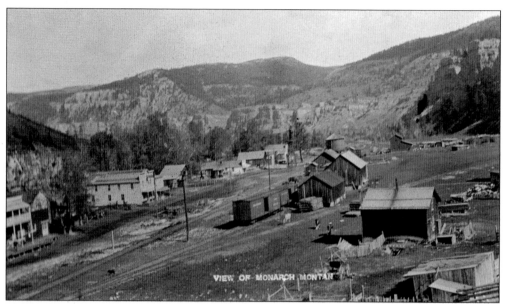

MONARCH. A scenic station formerly on the Great Northern Railroad and now on the highway in southeast Cascade County, Monarch is located 13 miles from Neihart. Mines opened nearby in 1889, the same year the Montana Central Railroad completed its tracks from Great Falls to Monarch; daily rail service continued until 1945. Monarch, on Belt Creek in the Little Belt Mountains, has become a popular recreation area. This view of the railroad town of Monarch was taken around 1908. (THM.)

MOUNTAIN ROAD TO NEIHART. One of the more scenic drives in Cascade County is from Great Falls to Armington Junction, then south on Highway 89 along Belt Creek, past Monarch and Neihart, to the ski lifts at King's Hill and down to White Sulphur Springs. This scene gives an idea of what the roads were like in the 1920s and 1930s when major improvements were made.

RESIDENTIAL NEIHART. This scene of the rugged mining town of Neihart shows: Fred Hart home (No. 66); unknown (No. 67); Lee Sing's Chinese Laundry (No. 68); C. H. Burchard home (No. 69); unknown (No. 70); Workman home (No. 71); Broadwater Group Mine tunnels 1, 2, 3 (No. 72); Neihart school (No. 73); Pete Rush/Henry Sutton home (No. 74); Bill Spence home (No. 75). (THM.)

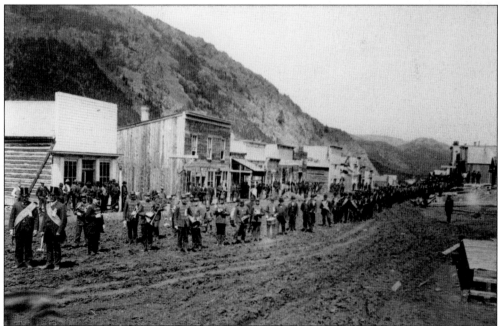

NEIHART MINERS' DAY. Neihart, a mining center started in 1881, is located 66 miles southeast of Great Falls. The town was named for James Neihart, the prospector who discovered rich silver-lead ore in the area. Pictured are miners in a parade June 13, 1892. (THM.)

WOLF IN GIBSON PARK. The mountains of Cascade County had many wolves in the early 1900s, and bounty hunters were hired to bring their number under control to reduce the threat to livestock. This image from about 1915 shows that not all wolves were wild—this is a caged wolf in the Gibson Park "zoo."

BIRDTAIL ROCK TODAY. Of all the scenes in Cascade County, the drive from Sun River Crossing to Whiskey Brown's, up Birdtail Creek and over Birdtail Divide, down to the Dearborn River is little changed from when Lt. John Mullan blazed his wagon road through the area. This image taken in the spring of 2010 showcases Birdtail Rock and is a tribute to the area ranchers who have been true stewards of the land. (Ken Robison.)

ABOUT THE GREAT FALLS/CASCADE COUNTY HISTORIC PRESERVATION ADVISORY COMMISSION

Over the decades, Great Falls has lost many historic buildings, such as the Grand Opera House, Tod Building, Conrad Bank, Linden Terrace Apartments. Fire and poor construction have taken some, poor judgment others. The purpose of the Great Falls/Cascade County Historic Preservation Advisory Commission (HPAC) is to provide leadership in the preservation of cultural, historic, and pre-historic sites, structures, buildings, and districts within the city and county. The HPAC works closely with the Great Falls/Cascade County Historic Preservation Officer.

HPAC advises the Cascade County Planning Board and County Commission, the Great Falls Planning Board and City Commission, the Downtown Action Alliance, and the Business Improvement District. Members of HPAC have knowledge in the areas of history, planning, architectural history, historic archaeology, cultural geography, and cultural anthropology. Ownership of property listed on the National Register of Historic Places also may qualify a person to serve on the commission.

HPAC promotes and reviews nominations for the National Register of Historic Places, identifies threats to National Historic Landmarks and sites, cares for Great Falls' first home, the Vinegar Jones Cabin, advises property owners, fosters preservation education, and promotes civic pride in historic preservation. Promotion of public awareness has led HPAC to sponsor the Historic Preservation Players in their performances of "How Great Falls REALLY began!" In addition, HPAC develops walking brochures including Great Falls Central Business Historic District Walking Tour for those who stroll through downtown Great Falls; River's Edge History Tour for users of the River's Edge Trail; and the Railroad Historic District Walking Tour for walking tours through Great Falls' railroad history.

Every year, during National Historic Preservation Month, HPAC hosts a public reception and presents Historic Preservation Awards to honor worthy preservation successes in Great Falls and Cascade County.

In the words of preservationist William J. Murtagh, "It has been said that, at its best, preservation engages the past in a conversation with the present over a mutual concern for the future." HPAC works to engage our community in a preservation conversation.

www.arcadiapublishing.com

Discover books about the town where you grew up, the cities where your friends and families live, the town where your parents met, or even that retirement spot you've been dreaming about. Our Web site provides history lovers with exclusive deals, advanced notification about new titles, e-mail alerts of author events, and much more.

Arcadia Publishing, the leading local history publisher in the United States, is committed to making history accessible and meaningful through publishing books that celebrate and preserve the heritage of America's people and places. Consistent with our mission to preserve history on a local level, this book was printed in South Carolina on American-made paper and manufactured entirely in the United States.

This book carries the accredited Forest Stewardship Council (FSC) label and is printed on 100 percent FSC-certified paper. Products carrying the FSC label are independently certified to assure consumers that they come from forests that are managed to meet the social, economic, and ecological needs of present and future generations.

FSC
Mixed Sources
Product group from well-managed forests and other controlled sources

Cert no. SW-COC-001530
www.fsc.org
© 1996 Forest Stewardship Council

Find Your Place in History.